THE COMPLETE BOOK OF HUMOROUS ART

The Complete Book of
HUMOROUS ART

BOB STAAKE

NORTH LIGHT BOOKS
CINCINNATI, OHIO

DEDICATION

To Kevin,
The Wild Child

The Complete Book of Humorous Art. Copyright © 1996
by Bob Staake. Printed and bound in Hong Kong. All rights
reserved. No part of this book may be reproduced in any form
or by any electronic or mechanical means including information
storage and retrieval systems without permission in writing
from the publisher, except by a reviewer, who may quote brief
passages in a review. Published by North Light Books, an
imprint of F&W Publications, Inc., 1507 Dana Avenue,
Cincinnati, Ohio, 45207. (800) 289-0963. First edition.

This hardcover edition of *The Complete Book of Humorous Art*
features a "self-jacket" that eliminates the need for a separate
dust jacket. It provides sturdy protection for your book while
it saves paper, trees and energy.

Other fine North Light Books are available from your local
bookstore, art supply store or direct from the publisher.

99 98 97 96 95 5 4 3 2 1

Library of Congress Cataloging-in-Publication Data

Staake, Bob
 The complete book of humorous art / by Bob Staake.
 p. cm.
 Includes index.
 ISBN 0-89134-623-6 (alk. paper)
 1. Cartooning. 2. Wit and humor, Pictorial. I. Title.
NC1320.S76 1996
741.6—dc20 95-35788
 CIP

Edited by Diana Martin
Cover and interior design by Sandy Conopeotis Kent

The permissions on page 132 constitute an extension of this
copyright page.

METRIC CONVERSION CHART		
TO CONVERT	**TO**	**MULTIPLY BY**
Inches	Centimeters	2.54
Centimeters	Inches	0.4
Feet	Centimeters	30.5
Centimeters	Feet	0.03
Yards	Meters	0.9
Meters	Yards	1.1
Sq. Inches	Sq. Centimeters	6.45
Sq. Centimeters	Sq. Inches	0.16
Sq. Feet	Sq. Meters	0.09
Sq. Meters	Sq. Feet	10.8
Sq. Yards	Sq. Meters	0.8
Sq. Meters	Sq. Yards	1.2
Pounds	Kilograms	0.45
Kilograms	Pounds	2.2
Ounces	Grams	28.4
Grams	Ounces	0.04

ACKNOWLEDGMENTS

While the process of writing a book of this type can be a frightfully solitary experience, there have been a number of people and institutions who offered invaluable help and assistance along the way. In no particular order, thanks go to:

Vicki Simington, Jill Armus of *Entertainment Weekly*, Maggie Pickard, Sam Scali and Gerry Rapp of Gerald and Cullen Rapp, Michael Drew of the *Washington Post*, Slug Signorino, Robert Zimmerman, Phil Marden, Zebraworks, Novachrome, David Lewis, Greg Albert, Jack Dickason, Rich Balducci, Keith Baizer, Sue Rempert of Ralston Purina, the Scripto Corporation, Paulette Fehlig, Keith Bendis, Richard McGuire, Vivian Walsh, Ryan Staake, Scott Kidman, Kinko's (at the last minute), Federal Express, Dan Martin of the *St. Louis Post-Dispatch*, J.S. Express, Guarnaccia's people, Jeff Seaver, *Communication Arts*, the underpaid and overworked folks at the United Postal Service, Viking Office Supply, Bill Mayer's Debbie, the *New Yorker*, Rita Morris of Tucker Wayne/Luckie & Company, Hallmark Cards, Paramount Cards, the Push Pin Group, Missa Mitchell, and of course, Schlitzey "the Wonder Pig."

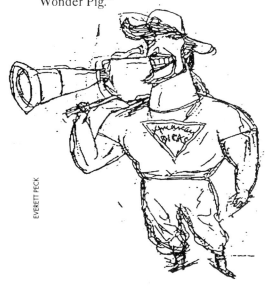

EVERETT PECK

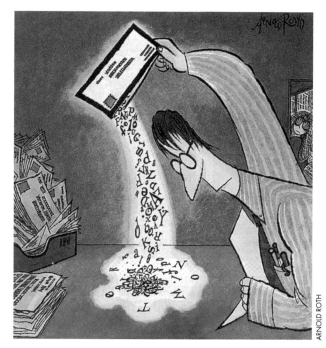

ARNOLD ROTH

ABOUT THE AUTHOR

The author of numerous books on cartooning and humor-oriented art, Bob Staake's *Complete Book Of Humorous Art* gives the reader a fascinating, insider's look at this unique art form. Respected by his contemporaries as one of humorous illustration's most versatile artists, Staake's work has appeared in the *Washington Post*, *Nickelodeon* magazine, the *Chicago Tribune*, *Sports Illustrated For Kids*, and *Parents*, and has been commissioned by such clients as Sony, McDonald's, SEGA, Warner Books, Turner Broadcasting, Coor's, Ralston Purina, Anheuser Busch, Kenner and The Ren and Stimpy Show. Currently, Staake is illustrating four children's books, designing and animating a CD-ROM game, and working on a new line of greeting cards. A collector of original cartoon art, 1950s furnishings, and Streamline Modern blonde furniture, Staake lives and works in Saint Louis, Missouri.

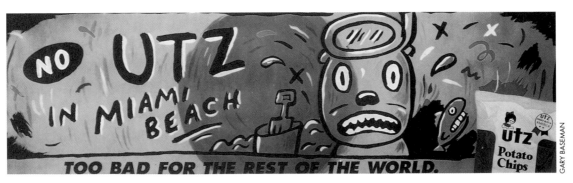

H.B. LEWIS

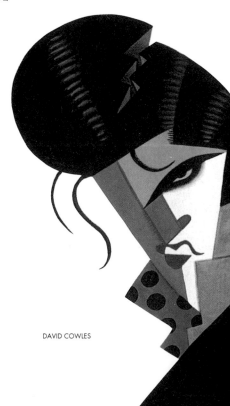

DAVID COWLES

INTRODUCTION

The fact that you're even holding this book in your hands is a miracle in itself.

When you write a book like this, or so I've been told, you're supposed to take your advance money, close down your business and personal life, take a room in a seedy motel, and shackle yourself to the computer for eight months, stopping only occasionally to partake of a little chicken bouillon for sustenance. Right. Like I have time for the bouillon.

A humorous illustrator's life is crazy enough what with constant deadlines, bumped-up deadlines, and we-need-it-this-afternoon deadlines, so to compound that lifestyle with the notion of writing a comprehensive book on humorous illustration is downright stupid, or insane, or both. Add the moniker of "complete" to a book on anything, and you and your publisher surely have a lot to live up to.

Yet a book, a truly good, comprehensive book on humorous illustration has been long overdue in my estimation, so when I suggested a thesis on the subject to my publisher, North Light, and they jumped on the idea, it suddenly became time to deliver.

If I've learned anything as a humorous illustrator, I've finally come to appreciate how fortunate I am to do what I do for a living, and the very notion that one can make a healthy income simply by sitting at a drawing table and creating funny pictures remains wholly ridiculous to me—especially when I'd do it for free. Yet day in and day out, the phone rings and there's usually someone on the other end who wonders if I'd like to draw a surfing chicken, a kid pouring maple syrup over his cat, or even a crab playing third base. The fact that I'm paid to draw stuff like that seems totally secondary at the time of the assignment.

And while I certainly feel able enough to filibuster on the subject of humorous illustration from a singularly personal perspective for page after page, I know that such a dialogue would hardly be in the best interest of a reader. Therefore, I felt it was important for me to interview friends, colleagues, and individuals regarded as the top practitioners in the field to get *their* take on the art form. After all, there may only be fifty ways to leave your lover, but there are an endless number of ways to approach humorous illustration, as the diverse samples in this book clearly exhibit.

But if the book is truly an important reference volume on the subject of humorous art, and I firmly believe that it is, it would lack multilayered insights were it not for the nineteen who shared their

observations with me. Through dozens of hours of phone interviews, numerous exchanges of correspondence, faxed notes, and awe-inspiring examples of their finished work and rough drawings, they were magnanimous with their time, observations, materials, and most importantly, their encouragement.

Sincere thanks go to Gary Baseman, Steve Bjorkman, Lou Brooks, Seymour Chwast, David Cowles, Jack Davis, Robert de Michiell, Peter de Sève, Drew Friedman, Steven Guarnaccia, Mike Lester, Mark Marek, Bill Mayer, Patrick McDonnell, Everett Peck, Robert Risko, Arnie Roth, Dave Sheldon, and Elwood H. Smith. Having talked at length with all of them, I'm grateful for hearing their insights firsthand and have developed an even better appreciation of their work, if that is possible.

It is important to explain a little about the process of writing a book of this nature. Unless they've ever done it (and this is my fifth book on the subject of humor-oriented art), I'm not sure anyone can really comprehend the extraordinary amount of minutiae that must be attended to when assembling a publication of this scope.

After sending hundreds of "calls" for humorous illustration samples to humorous illustrators, eighty-five percent of them miss the deadline for submissions. Naturally, a new deadline is then established so that sixty-five percent of the artists can miss that one as well. Six months later, after all the art has finally staggered into St. Louis, there are reprint releases to sign, permissions to be secured, art to be shot, transparencies to be cataloged, tearsheets to be logged, captions to be researched, manuscript points to be cross-referenced, phone interviews to be transcribed, facts to be checked, art to be coded and assimilated, indexing to be painstakingly researched, and in the middle of all these details, I'm expected to write some semblance of a cohesive, insightful and comprehensive manuscript of not more than 25,000 words (I hit that in chapter two and was forced to dramatically trim back the thesis).

In the end, I'll surely receive a letter or phone call from someone who's furious that I didn't reprint a single sample of their work. It always happens.

Yet for this book, close to 2,700 samples of humorous illustration were sent to me for review. Now remember: I *like* humorous illustration, and nothing would please me more than to publish a book three-feet thick filled with funny art. Yet publishing has its limitations, and in this case, I was obligated to select 229 pieces of art for the book. Hey, I cut *my* work, I cut the work of my *friends*, but always for a good reason.

In the end, art was selected that enhanced, complemented, supported or even disagreed with points in the manuscript, and it is my firm belief that the pieces chosen are representative of the finest in contemporary humorous illustration.

But you be the judge. Read this book, look at the art, and perhaps become inspired. If you then gain a greater appreciation for the unique art form of humorous illustration, then this book experience can honestly be called "complete."

Bob Staake
26 October 1994
Saint Louis, Missouri

MAKING [NON]SENSE OF HUMOR

ART THAT TICKLES OUR FUNNY BONE

You can run from them, but you can't hide from them.

Aliens? Cockroaches? IRS investigators? Nah, a little less ominous than all that. I'm talking about *humorous illustrations*.

Today, the use of humorous illustrations in publishing, advertising, communications and packaging has never been greater. Open any self-respecting trade or consumer magazine and find a healthy smattering of pithy illustrations to drag you into the articles. Bump into an ad for potato chips, and chances are good that their low-sodium-fat-cholesterol-calorie contents are hyped by wacky, anatomically-askew characters. Even greeting cards, once the last bastion for saccharin-sweet platitudes and painful graphics, have been taken hostage by humorous words *and* art.

In many ways, a good humorous illustration is like a wild party—it's tough to ignore, and once you notice it, you can't help but want to join in.

Indeed, in a contemporary society bloated with the harsh realities of life, humorous illustrations allow us to peek into an unreal world where anything can happen, and routinely does. Where else but in a humorous illustration can one come face to face with noses shaped like ice cream cones, hairdos higher than the Chrysler Building, and bodies shaped like over-boiled bagels? In reality, correcting two of those characteristics would require the services of a talented surgeon and a good personal trainer, and for the other, a simple change in barbers might be in order, yet in the illusory world of humorous illustration, these graphic traits are hardly objectionable—in fact, they're welcomed!

And if one is perceptive enough to detect a gradual rise in the use of humorous illustration in a mélange of communicative applications, the reason for the increase may be as simple as art direction's reflection of pop society as a whole. "Hu-

FUN WITH FLOSS Elwood H. Smith's self-promotional ads in *American Showcase,* the directory of illustration, are always a treat, and are intended to show off Smith's decidedly tweaked sense of humor and witty graphic approach.

mor is *everywhere* now," says Lou Brooks. "I mean, just turn on your TV and you can't go three channels without seeing a guy standing in front of a brick wall telling jokes. Today, most of the art directors who are doing the hiring grew up watching shows like 'Saturday Night Live' and reading *National Lampoon*, so they understand that people *like* to smile."

Happily, we're all lightening up, and art directors, editors, creative directors and even clients simply can't avoid the fact that the buying public appreciates, and most importantly, *responds* to humor. Therefore, it should come as no wonder that appropriately placed humorous illustrations are used to snag the attention of magazine readers, move boxes of cereal from glutted supermarket shelves, or persuade a greeting card buyer to make a purchase.

Silly, ridiculous, wacky or just plain distorted for the sake of being distorted, good humorous illustration takes no prisoners, straddles no fences, and makes no excuses.

DEFINING WHAT'S FUNNY

The most obvious difference between a "straight" illustration and a humorous illustration is the latter's routine use of graphic distortion. While straight illustrators carefully and meticulously render everything from fingers to taxi cabs with a general faithfulness to their actual design, humorous art celebrates the illustrator's freedom to distort, exaggerate or tweak his graphics on a whim and nothing more.

If traditional illustrators must resign themselves to visually reiterating the way

a pig really looks, the humorous illustrator is afforded the freedom to recreate the pig, and with that kind of freedom, anything can happen—and often does. in such an instance, humorous illustrators are like ge-

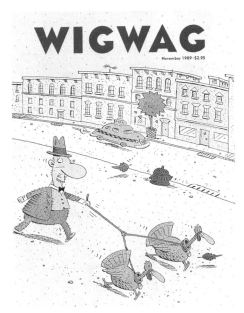

ART YOU WANT TO GOBBLE UP! While *Wig Wag* died a fast and relatively painless death, they were able to get in this cool cover by Elwood H. Smith. While this art "takes no prisoners or straddles no fences," it does take two turkeys for a walk on a crisp fall afternoon.

I GOT THE MUZAK IN ME You can almost hear the Barry Manilow music reverberating in this elevator. "I deal very generically with the subject matter of a manuscript," says Arnold Roth. "What I draw isn't in the article, but I draw something about the article."

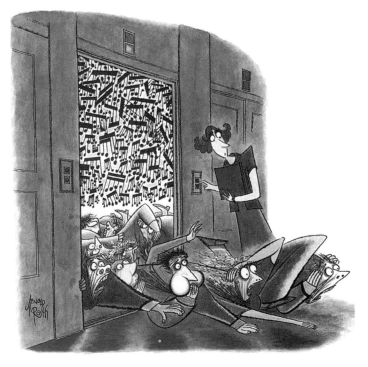

netic scientists, the difference being that when we create a mutation, we do it with a pen, not a test tube.

Humorous illustration, truly *good* humorous illustration, is unrestrained by any accepted rules or any need to draw people, objects or environments in anything but "whimsically distorted" terms. It would be difficult, for example, to encounter the humorous illustrations of a Jack Davis, Elwood Smith or Mike Lester and experience them as anything but funny. These humorous illustrators understand how to communicate humor in no uncertain terms by infusing their work with an undeniable zaniness by exploiting the art form's general lack of rules.

Jack Davis's illustrations, for example, contain enough combustible energy to power a medium-sized city for a month. Mike Lester's graphics almost appear to spontaneously animate on the printed, two-dimensional page. Elwood Smith's characters grunt, groan, growl and exude sounds usually reserved for whoopee cushions or elderly dogs. Who wouldn't smile when assaulted in the eyes with slavishly funny stuff like that?

LOOKING AT LIFE THROUGH FUNNY-COLORED GLASSES

But it is Elwood Smith's *perception* of real life as well as his point of view that causes him to create illustrations that are decidedly humorous. "People ask me if I really see life in a strange way," says Smith, "and as the years have gone by, I realize that I do. When I see someone walking with funny shorts on the beach, I see that differently than most people do. In my mind, I'd stretch the character so that his legs got skinnier, his shorts balloonier, and maybe just a few hairs on his head. What amazes me is when a client tells me that one of my characters looks a little too weird. That always shocks me because my characters don't seem that far out at all."

And while one can be taught the basics of drawing, painting and the application of various techniques, the notion of *teaching* one to be humorous might seem an impossible feat. How, for example, would one teach someone that the sight of a nun slipping on a banana peel is funny, or that a cheesy photo of a chimp dressed as a Fortune 500 CEO should be viewed as nothing less than downright hilarious? To appreciate humor requires that individuals have their own innate sense of what's worth laughing about.

"I'm not sure that funny things can really be explained," says Bill Mayer, "and I don't think you can teach someone to have a sense of humor. I have a friend who has absolutely no sense of humor, so when she finds something to be stupid, her husband then knows it must be really funny—he uses her as sort of a reverse barometer. It's hard to imagine, but there really are people out there that just don't see life humorously. To me, it's funny to see a drawing of a fat lady using a cheese grater to shave fat off her butt."

"I guess my sense of humor," Mayer continues, "tends to have a little bit of an edge to it, especially my drawings of weird animal/monsters. I guess that's why Hallmark and Disney haven't worked their way around to me. I detest that sort of stuff anyway, so I guess that's why my humor is on the edge. Actually, I look a little like the monsters that I draw."

FUNNY IS WHAT FUNNY DOES Currently, Bill Mayer finds humor in monsters and uses his airbrush to engender weird mutations who ride even weirder mutations. But is Mayer's stuff funny enough for Disney—or Hallmark?

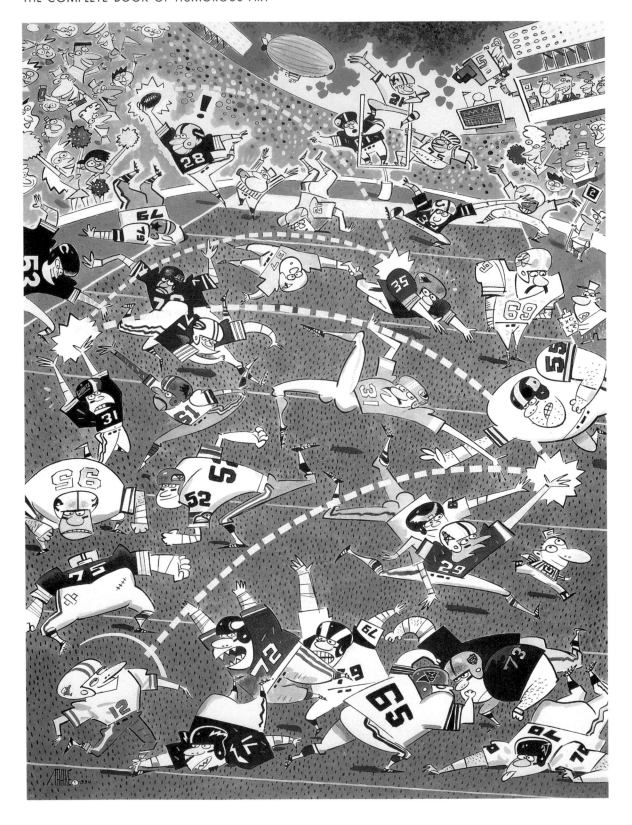

Yet if humorous illustration is arguably enjoying a new renaissance, many recall when the art form wasn't in vogue. "The communications industry is cyclical," Gary Baseman points out, "and humorous illustration hasn't always been in fashion. When I got involved in illustration in the early 1980s, you rarely saw humorous illustration being used. What was 'in' then were illustrations that were moody, dark and pouty. That seemed to get people's emotions going. But later in the 1980s, this new whimsical trend of humorous illustrators started to get recognition."

HUMOROUS ART? "EYE! EYE!"

Yet if humor is used more today in the communicative fields, it is because the humorous illustrator has become more sophisticated. The sophomoric, graphically-vulgar practice of simply banging out a funny, cartoony drawing with little or no planning or forethought isn't enough these days, and while sketching comical characters might elicit a smirk from the pre-pubescent set, that same graphic approach may turn off a discriminating aesthete.

Today, many contemporary humorous illustrators elevate their work to decorative design by paying as much attention to composition, color, concept and presentation as they do to humor-evoking technique. Steven Guarnaccia, Robert de Michiell, Steve Bjorkman, Seymour Chwast, Robert Risko and David Cowles, to name but a few, do not merely create funny illustrations, but wrap their art in a sort of elegant packaging that exudes a sophisticated flair.

LONG BOMB In this piece commissioned by Hershey's and the NFL, slapstick action is the key, and while the scene is obviously distorted, the exaggeration isn't grotesque.

"I tend to use a quieter, sophisticated type of humor in my work," says Steven Guarnaccia. "Part of that was developing my style which essentially strips things down to their absolute basic elements. I also love to interject my work with a certain surrealistic feel. Only recently, I realized that I was as much a designer as I was a humorous illustrator."

"One of the things I draw on to make a successful humorous illustration," Guarnaccia continues, "is composition. Composition is really a conceptual tool on a kind of decorative level. But I didn't always accept my interest in the decorative because I thought it was supposed to be sort of frivolous. But I'm really starting to embrace the decorative aspects and design elements of my work."

I certainly can relate to how it took time for Guarnaccia to finally acknowledge and accept his interest in the decorative aspects of his work. Trained in college as an editorial cartoonist and mentored under Paul Conrad, the three time Pulitzer Prize-winning political cartoonist of the *Los Angeles Times*, I was taught that cartoons (and I suppose humorous illustrations) were merely the vehicles for getting across specific ideas.

Aesthetic aspects, I always thought, should be subservient to an idea, so I would always place a premium on the creation of ideas and let the graphics, drawing and other decorative aspects share the back seat. In fact, I was so firmly convinced that if an editorial cartoon's idea was strong enough, it could easily be communicated with a drawing composed of nothing but stick figures. It wasn't until I made the career shift from editorial cartooning to humorous illustration in 1986

that I began to realize the importance of an illustration's decorative features, even though it took me a long time to finally assimilate some semblance of design into my humorous illustrations.

It literally took me years to comprehend that humorous illustration is essentially viewed by others as a predominantly visual experience, and it required me to make a concerted effort to get a little more quality artwork into my illustrations. Only recently have I felt comfortable in creating humorous illustrations that work immediately on a visual level, and accept the decorative aspects as indeed meritorious.

Today, David Sheldon's illustrations are unmistakably humorous, but they weren't always. Originally, Sheldon worked in what he called his "scary" style, a dark, serious pencil approach that he employed to illustrate non-humorous articles on drug abuse and child molestation.

But after a couple years of illustrating in this manner, Sheldon began working in gouache in hopes of giving some humorous balance to his work. "It was hard making the change," recalls Sheldon, "because all through college, everyone around me insisted that cartoon imagery wasn't acceptable as art. I just pushed that stuff out of my mind and started to realize that I *like* humor and cartoons."

Growing up in the 1960s, Sheldon admits to watching "a lot of television," and it's the distinctive look of 50s and 60s commercial animation on which Sheldon has built his humorous illustration style. In fact, Sheldon's design of the "Log" and "Sugar Sod Pops" phony commercials that air on "The Ren and Stimpy Show" evoke a decidedly 1950s aesthetic, an evocation that enables Baby Boomers to journey back to their childhood.

"The design of commercials back then was so beautiful," says Sheldon. "The whole economy of word, the economy of line, the economy of art. I don't know if that was because of low advertising budgets or if it was the style of the time, but I responded very emotionally to that look. My work is always changing, but my ultimate goal as a humorous illustrator is achieving that look. I don't think I do it as successfully as those guys, but I try to."

HUMOR NEVER LOOKED BETTER (OR MORE SOPHISTICATED)

If humorous illustration has been able to distinguish itself in the 1990s, it is because the profession has never before been filled with so many sophisticated, able practitioners. Increasingly, humorous illustration is being treated as an art form, due greatly to the creative efforts of people like Steven Guarnaccia, Lou Brooks,

PITHY PAPER I do a considerable amount of work in the children's market and on packaging for kid's products, and I've come to appreciate the importance of fun art for fun art's sake (Yucks Gratia Yucks).

Elwood Smith and Gary Baseman who have been able to secure high-profile editorial and advertising assignments that individually help themselves, but have an ancillary, legitimizing benefit to the profession as a whole.

Today, a number of humorous illustrators infuse their work with dizzying levels of graphic and aesthetic sophistication that only helps inject an air of excitement into the art form. At first glance, Mark Marek's nightmarish humorous illustrations appear downright sophomoric but are brilliantly original, J. Otto Seibold's minimalist graphics are almost intoxicating, and Robert Zimmerman's characters appear to be the offspring of a linoleum block that had an affair with a computer.

Brooks's contribution to the field is particularly noteworthy because he, like Seymour Chwast before him, greatly broadened the definition of what humorous illustration can be. In many ways, Brooks's impact is similar to the effect that Andy Warhol had on the world of art. If Warhol said it was OK to call soup cans art, Brooks said it was OK to call old comic book imagery humorous illustration. Often recycling and updating old, already existing images, Brooks has always honestly asserted that his work is anything but one hundred percent original.

"When I started doing my humorous illustration," says Brooks, "it was considered fairly outrageous. In a way I think I was like Elvis. He really was a purveyor, but not necessarily an originator. Elvis wasn't the first guy to sing like that, but he really said that it was OK to like this kind of music."

As revolutionary and groundbreaking as Brooks's work was in the 1980s by mak-

COMIC COVER Recycling and building on comic imagery from the past, Lou Brooks helped expand the definition of humorous illustration. "I see my work," says Brooks, "as a complete restatement of a lot of things that existed a long, long time before I got involved in humorous illustration."

VISUAL EXPERIENCE It literally took me years to realize that there's nothing wrong with humorous illustration that works on a decorative level.

A classic piece of clip art, circa late 1940s

ing graphic reference to everything from carnival signage to romance comic books, his lingering effect can be seen every day in ad campaigns, editorial layouts and television commercials that employ clip art and other public domain imagery from the '30s, '40s and '50s.

SOPHISTICATION GONE MAD

But if humorous illustration is increasingly practiced by a more sophisticated, creatively progressive collective of talented individuals, it certainly doesn't mean that others do not still approach humorous il-

TO CLIP OR NOT TO CLIP
While Lou Brooks's graphics have helped pave the way for a new acceptance of mid-century, upbeat (copyright-free) clip art, he doesn't fear this trend. "If an art director wants that Lou Brooks touch," says Brooks, "then they're going to have to come to me."

lustration from a more cartoon or comic-oriented aesthetic.

Considered by many to still be the reigning "king" of humorous illustration, Jack Davis freely admits that his work "isn't very sophisticated." A self-described "meat-and-potatoes man" who has always approached humorous illustration from a cartoon perspective, one gets the sense that Davis doesn't necessarily dislike graphic sophistication, but maybe doesn't quite trust it.

"I think my stuff appeals to people who don't have any taste," laughs Davis. "I even look back at my old work in *EC Comics* and *The Tales From the Crypt* stuff and think God, they were awful. But over the years, you improve your work and try to do better."

Synonymous with *MAD* magazine, it's indeed interesting that Davis now feels that the *MAD* of today has begun to reflect the more "vicious and raunchy" nature of humor. "When I look at *MAD* now," says

Davis, "I kind of cringe. I just don't see some of the humor, and I think you can be funny without being vicious or cruel. But then maybe I'm just old-fashioned, and it could just be the changing times."

Patrick McDonnell also laments what he sees as a general lack of sophisticated humor in almost every area of American society—from books to television. Mc-Donnell has long approached his humorous illustration work from a comic strip perspective, and with the launch of his syndicated strip, *Mutts,* may end his impressive career in humorous illustration.

"We're definitely not on the road to sophistication," complains McDonnell. "You see a lot of wacky drawings that are considered humorous illustration, but when you really look at them, what's the joke or the thought behind the art? I think many humorous illustrators are more interested in making their figures look funny, wild and graphic. The human subtleties, those little things that make you laugh, just aren't there. It's fun to look at,

NO BULL Bill Mayer loves to draw animals, even when they're in crisis over their identities. The jury's still out, however, whether the humor of this piece is sophisticated or not.

but as far as being sophisticated, I don't think it is."

Yet, to foresake the sophomoric, Bill Mayer asserts, might eliminate a whole host of humorists—illustrators included. "Certainly sophistication shouldn't be a criteria for being humorous," he says. "If that were the rule of thumb, you could rule out quite a bit of humor."

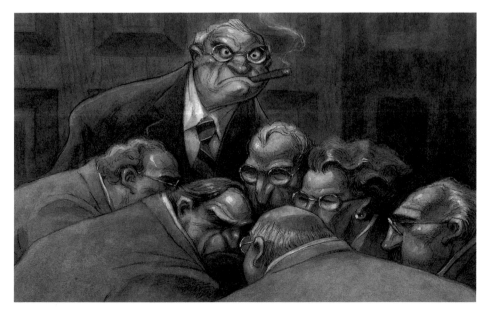

HUDDLE UP To humorously illustrate a *Washington Post Sunday Magazine* cover about high-level Capitol Hill meetings, Peter de Sève shows a cigar-puffing politico who is upset that you, the reader, have barged in on their discussions. Talk about an idea that causes the reader to interact! "My subject matter," says de Sève, "has never been serious, so I have never considered myself to be serious."

A devoted fan of *MAD* magazine (in particular the work of Jack Davis and Mort Drucker), David Cowles offers an interesting hypothesis regarding what can only be termed as "sophistication backlash." "Humorous illustration just went through a whole period of cerebral kind of stuff," Cowles points out, "and I think we'll be seeing a lot of *MAD* magazine type work coming up. I think *MAD* will be rearing its ugly head again as an influence. That would go along with the whole Slacker/Generation X thing. I mean, look at *MAD*. It's kind of sloppy, and it almost has an alternative feel to it."

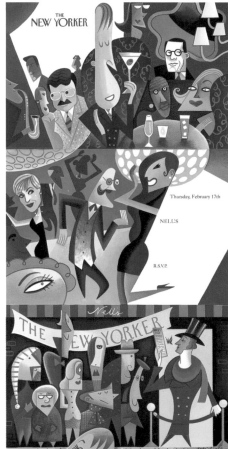

THE PARTY'S OVER, SO DON'T EVEN THINK OF CRASHING IT! Robert de Michiell's inventive, sophisticated humorous illustration approach perfectly complements this party invitation for his sometime employer, the *New Yorker*.

THE ROLE OF HUMOROUS ILLUSTRATION

STANDING UP ON PAPER

The assertion that a humorous illustration should be intrinsically funny means that the role of the humorous illustrator is generally analogous to that of a stand-up comedian. The comedian may use words to express funny stories and jokes, while the humorous illustrator uses a pen and a piece of paper to do pretty much the same thing, minus heckling, of course, and the two-drink minimum.

Yet on top of that, there are many different stand-up comedians who approach comedy in varied ways. Some are more observational and satiric, while others are content to build entire routines on slapstick and puns. There are even comedians who smash melons with sledgehammers or ones who pepper their routines with enough four letter words to insure jobs for a fistful of network censors.

And if humorous illustration is parallel to stand-up, it means that like the comedian, the humorous illustrator must decide what sort of "act" he's going to put together.

STOP, LOOK AND LAUGH

Arnold Roth firmly believes that his humorous illustrations should cause a reader

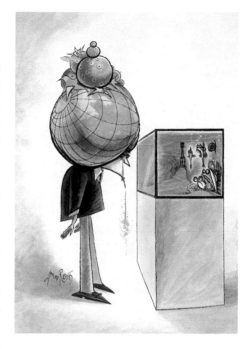

IT AIN'T HEAVY, IT'S MY HEMISPHERE Arnold Roth is masterful at creating humorous imagery that can only be deciphered by delving into the manuscript which it illustrates. "In my work," says Roth, "the idea and the drawing are very sympathetic to one another. If one is too weak, it sort of invalidates the other."

to screech to a stop. "My role is one of problem solver," says Roth, "by creating an attractive, entertaining, funny and eye-catching drawing that will bring people into the article. Usually, I won't specifically draw something that's in the article, but I'll try to give the reader some idea of what the story is about. [I mean, *no one* decides they're going to read an article first and *then* look at the illustration;] they look at the illustration, which hopefully gets them into the article. It's nice if somebody says, "Gee, this is a funny picture—I wonder what the article is about?' "

Encountering Roth's drawing of a hapless soul wearing the weight of the universe as if it were a fedora, it would be tough to shun the article that it illustrates, if only to get a better idea of the enigmatic drawing's connection to the text. In this case, Roth's illustrated riddle augments an article entitled "Stress: The Urban Killer."

Humorous illustrators like Peter de Sève create illustrations that employ humor in subtle ways. De Sève expertly combines aesthetic realism with a degree of anatomical distortion to create hybrid illustrations that are unmistakably humorous. It's just that the humor doesn't slam you right between the eyes.

"I always try to find the purest, cleverest way to visually describe what an article is about," says de Sève. "I try to distill the manuscript and add some sort of complement. That really works best for me, and then I'm not just illustrating an article. If I can bring that something extra to the article, then I've been successful in performing my role."

Regarding his ideas as paramount, Gary Baseman sees his role as that of an "imagineer," a Disney term for a person who is paid to brainstorm creatively. "I wear a lot of different hats," says Baseman. "Sometimes my role is that of a cartoonist, other times I'm a painter, often I can be a writer, or simply a drawer. My job is to deal with a mass audience and solve a problem. If I'm illustrating a magazine article, my job is to get across a thesis of what the story is about and hopefully attract a reader's attention."

Yet beyond the basic job description, Baseman ideally envisions himself as a facilitator of sorts, and wants his reader to interact significantly with his humorous illustrations. "I expect a reader to contribute a little bit of themselves when they look at my pieces," says Baseman, "instead of just sitting there and being stimulated by the actual image."

SLAMITUDE OR SUBTLETY: EITHER WAY, YA GOT HUMOR

Whether they slam you between the eyes like a soggy brick, or tickle your funny bone with their sardonic whimsy, humorous illustrations can possess varied levels of humor. Here again, it is the humorous illustrator who determines what type of visual humorist he will be, and to what degree he will communicate his humorous point of view.

Patrick McDonnell, for example, is keenly appreciative of humor that is less obvious, and manifests this appreciation in his humorous illustrations with a

RISKO'S "IN" CROWD "My objective," says Robert Risko, "is to constantly question the media world, to take on imposters and phonies. That may seem grand, and I wouldn't say I'm like Woodward and Bernstein investigating Watergate, but by impersonating the external that we see, maybe we can find some truth in the person who's under scrutiny."

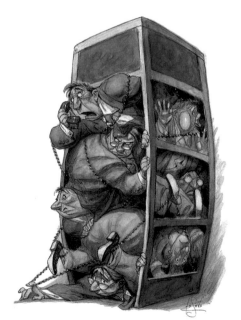

EXTREME CALL-WAITING Peter de Sève injects a stunning level of animation and kinetic energy into this phone booth. While his drawing lacks a single action line, flying bead of sweat or any other cartoon hieroglyphic, you *feel* the phone booth ready to burst and can almost hear the stressing of metal.

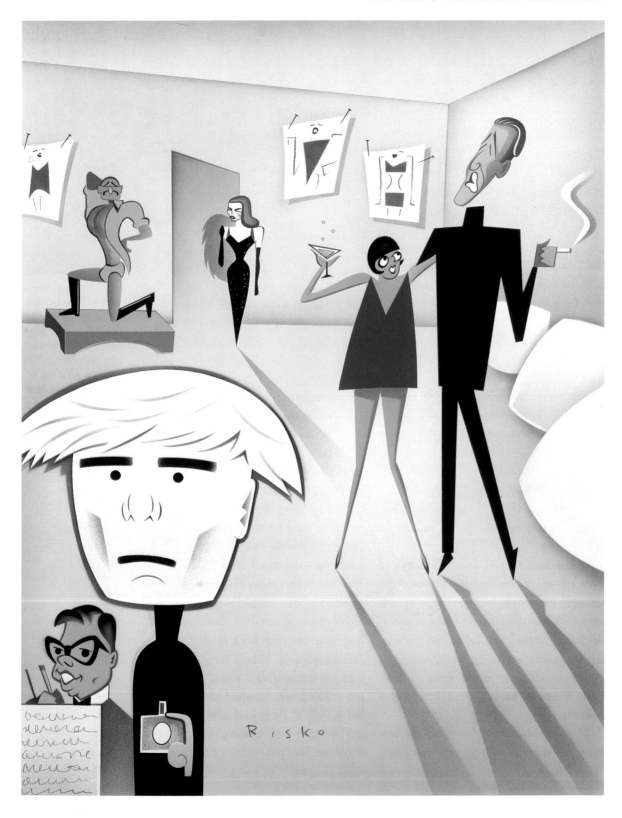

graphic simplicity. McDonnell's drawing style, best described as understated for its economy of line and less-is-more sensibilities, can communicate a mountain of humor by simply opening a baby's mouth or adding a wagging tail to a dog.

"For me," says McDonnell, "the humor just evolves with the drawing. What's important is that I care about each character that I draw. I think the exciting part of my humorous illustration is in trying to make these little line drawings come to life. When you look at my characters, you should really get a sense of what my character is feeling behind those two black dots for eyes."

Undeniably one of the nation's most brilliant caricaturists, Robert Risko's graphic impersonations of celebrities ultimately function as humorous illustrations. "Humor is truth," says Risko. "Things are funny when they are honest. It's like when a child says something that an adult would never say—that's funny, because usually it's what everyone is thinking, but not saying. What I try to do is humorously point out the folly of the man who is constantly striving to be a sort of 'master of his universe'."

In contrast, Drew Friedman's sense of what's funny is considerably darker, if not sinister. Friedman, perhaps best known for his stipple drawings of B-grade entertainment industry has-beens and wart-encrusted, saliva-on-the-chin retirees, finds humor in tragedy, and there's nothing even remotely subtle about Friedman's delivery.

"I enjoy when horrible things happen to close friends of mine," says Friedman, "I just think that's funny. To me, there is beauty in ugliness, and I enjoy drawing all

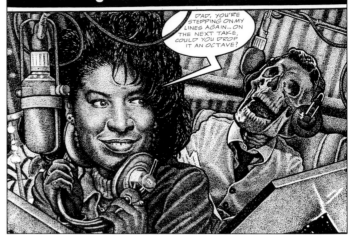

A Recording Session With Nat And Natalie

DAD, YOU'RE STEPPING ON MY LINES AGAIN... ON THE NEXT TAKE, COULD YOU DROP IT AN OCTAVE?

the wrinkles, warts and all. I heard there was a guy who actually spends a lot of time counting all the liver spots I've put on people. I'm still waiting to hear from the guy that is going to count every stipple dot I've ever drawn."

It's Friedman's vitriolic, at times vicious, sense of humor (channeled through his pointillistic illustrations) that has often gotten him into trouble. When Friedman drew a cartoon in *National Lampoon* called "The Incredible Shrinking Joe Franklin," Franklin sued for forty million dollars, a sum Friedman says he would have "gladly paid, but at the time I think I only had one hundred dollars in my checking account." Friedman also commented in cartoon about the long rumored, unsubstantiated love affair between Rock Hudson and Jim Nabors, causing Nabors to initially react with the threat of legal action. And according to Friedman, Natalie Cole's record label pulled an estimated one million dollars worth of advertising from a trade magazine that published a Friedman cartoon essentially accusing Cole of robbing her father's (musical) grave.

MILLION DOLLAR DOO-DLE "At first this may seem like a cruel drawing," admits Drew Friedman, "but maybe taking her [Natalie Cole's] father's tapes and singing to them was out of line. To renew your career that way is sort of like robbing the grave, but I suppose if anyone had the right to do it, she did."

Indeed, Friedman's sense of humor is wickedly nasty, and I can think of no better way to spend a rainy Sunday afternoon than rolled up in a corner reading *Warts And All* or any of his other anthologies, giggling with an abandoned, sinister delight. But today, Friedman admits that his sense of humor has changed as he's matured. "I no longer have any interest in being sued," he says. "Maybe I'm kidding myself, but I don't think I'm as much of the wise guy that I once was. I have a mortgage now, so I don't really want to be the wise ass anymore."

HUMOR EXPOSED While Patrick McDonnell has been somewhat skeptical about the benefit of running ads in illustration directories, this was by far the most successful self-promotional ad he ever ran. The simplicity of the image is obvious, the humor decidedly slapstick, and the white space is, well, *really* white.

THE TIME FOR HUMOR

All illustration, humorous or not, comes as a result of the need to graphically augment something else. For example, a magazine article may need to be accompanied by a lead illustration, a book may require a cover illustration, and even a greeting card needs a visual element to support its page-three sentiment.

Therefore, it is the general tone of that article or manuscript that determines how it is to be *best* illustrated—straight or with humor.

Needless to say, it would be inappropriate to illustrate the cover of *The Gulag Archipelago* with a humorous doodle of Aleksandr Solzhenitsyn in leg irons, and there are better ways to illustrate an article on euthanasia than with a funny scene of a doctor, a patient, and a hypodermic. And that greeting card? It's intended to console someone at the loss of their elderly mate, so a funny drawing of anything other than a lily is out of the question.

But if the book is a collection of humorous essays on travel, the magazine article

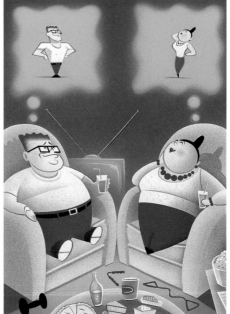

THEY'RE CHUBBY, AND THAT'S THE TRUTH Robert Risko produces a pair of portly couch potatoes (or perhaps more correctly, a pair of chubby club chair yams) that appear lost in their dreams. "I remember watching the old Dick Cavett Show once," recalls Risko, "and this guy who was a professor of ideology, or religion, or philosophy said that the only place you can find truth is through clowns or saints."

explains ostrich farming as an investment, and the card equates in a humorous way a fortieth birthday with, say, a proctology exam, then augmenting the pieces with a humorous illustration or two would not only be appropriate, doing so would help visually convey to the reader that the

book, article and card contain a certain degree of humor.

The humorous illustrator must then envision an illustration which must work within general parameters over which he has little control. For example, both the art director and the illustrator would have to agree (though this may be an unspoken point) that any article on ostrich farming must include a drawing of an ostrich—preferably as its focal point. Furthermore, the art director may ask that the humorous illustrator create a drawing that takes up a full page, a drastically horizontal or vertical space, or even an area slightly larger than a postage stamp—all considerations that he must take into account when creating his illustration.

"It takes a lot of art to fill those magazine pages," says Gary Baseman. "A lot of type would look dull, and even the articles themselves can be pretty boring. That's why you see so many humorous illustrations in computer magazines."

Nonetheless, there are still times when art directors make illustration assignments that ultimately can be judged as inappropriate. "I remember seeing an ad once," recalls Steve Bjorkman, "that showed a photograph of a family wrapped up in blankets, sitting on a couch and shivering, and it really looked dumb. Now if the art director assigned a humorous illustrator or a cartoonist to draw that scene, they would have exaggerated it and it would have looked much better. On the other hand, I've been asked to illustrate things that should have been photographed because that would have been the best way to communicate the subject matter."

FUN WITHIN FOUR WALLS

While humorous illustrations are predominantly used for the seemingly altruistic purpose of coaxing someone to read a patch of otherwise gray copy, or for the decidedly capitalistic intent of prodding a buyer to purchase specific goods and services, humorous illustrations at first satisfy the simpler purpose of making their creator laugh, smile or grin.

Every time I sit down at the drawing board in my cluttered studio and face a new project, my primary goal is always the same—to have fun. Nothing is more contagious than a funny drawing, but the only way I can create that funny drawing is by making a conscious effort to please myself—first and foremost. If I'm able to humor myself, chances are good that I'll be able to humor the art director, editor, reader or potential buyer that later en-

MONSTROUS SCENE
Steve Bjorkman's light, airy and understated humorous illustration style lends itself perfectly to advertising. "My job," says Bjorkman, "is not to make myself look good, my job is to visually communicate an idea that best serves other people."

ICT From Marshall.
Because Just Getting To Work
Is Risky Enough.

counters the illustration.

After accepting the aspects of the assignment that I have no control over (certain imagery must be drawn, in a certain size, in a certain way, etc), I then attempt to relax, have some fun, and please myself. *That* becomes my immediate purpose for the illustration, and comes before any greater purpose of snagging readership or selling product. And if I can create my work with little or no client interference, that client will get the best work out of me, and I do not know of another illustrator—humorous or not—who would disagree with that statement.

For example, I was recently assigned the task of illustrating a football game on the back of a box of *Rice Chex* cereal. After working out the basic parameters of the project with an art director at Ralston Purina, I looked at the layout, read my scribbled notes, turned up the stereo, pulled out a crisp pen, and strove to have some fun.

Reduced to that simple level, it's hard not to let my rough sketch take on a life of its own and become an exercise in lighthearted spontaneity. A lyrical wide receiver being held at the ankle, an offensive end pairing off with a butt-bandaged defensive end, a quarterback perfectly lofting the ball into the hands of a stretching tight end. Almost all the humor is choreographed, placed and integrated into this rough sketch, and once I am completely satisfied with the results, it is shown to the art director for comments, changes and suggestions. If the art director spends more time laughing than requesting changes, I've been successful with the rough sketch.

I then create the final color illustration

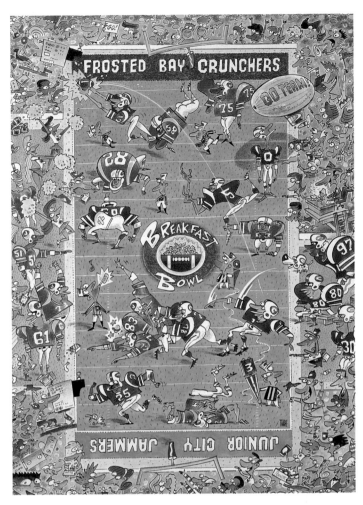

still attempting to keep myself amused. A sportscaster that looks more Walter Winchell than Dave Madden? Fine. A blimp about to crash? Fair enough. A duck waddling on the field? Why not? If I'm having fun drawing this stuff, a kid (or adult) should have fun as well scanning the box between chomps of Chex.

But more important than individual instances of humor is the overall, broad humor of the illustration. Do the characters *look* funny? Does the scene have the proper level of chaos? Is there a strong sense of action within the illustration? If these things are present in the illustration,

A STADIUM FILLED WITH FUN When I create one of these big, complicated scenes for a cereal box or product packaging, the bulk of the work is creating the pencil sketch. It's in that sketch that all the kinks are worked out, but it really serves as a reminder, not necessarily a perfect blueprint, for my final art.

then I'm smiling. Like the doctor who can tell when a bone is healing correctly, a good humorous illustrator knows when things are working—and when they're not.

Yet on top of all that, one of the reasons that clients tend to call me to create what I call "orchestrated chaos" scenes is because I can turn them out on very short notice. While most humorous illustrators I know would think twice about accepting a complex assignment like this if given a two-week deadline, often I am approached to produce drawings like this in two *days*. Naturally, I'm able to negotiate pretty healthy fees when creating complicated art of this nature. The complexity of the illustration alone is one aspect that allows me to set a higher fee, and additionally, because the client has a short deadline requirement, this too means he will have to pay a premium for the illustration.

With humorous crowd scenes like this, I've found clients relieved that I'm able to meet what they had imagined would be their impossible deadline, so if the worst that happens is paying almost twice as much as they had budgeted for art, they're more than willing to do so. Chaotic humorous art like this seems to be a little niche for me, and there aren't too many of my peers who are crazy enough to take assignments like these.

NOW READ THIS!

With regard to humorous editorial illustration, it is generally understood (but unspoken) by editor, art director, and illustrator that the illustrator's role is like that of a sideshow barker. As a reader flips through the pages of a magazine, under ideal circumstances it is hoped that the art—illustrations, photographs, caricatures, even large type headlines—becomes compelling enough to seize a reader's attention.

It is therefore incumbent on the artist to create a piece that piques curiosity—and compels the viewer to read the headline, and then the manuscript's lead. It then becomes the writer's responsibility to maintain the reader's interest throughout the article.

Thought of by some as a latter-day Lichtenstein, Lou Brooks's bold, graphic, in-your-face, humorous illustrations scream forth from the printed page. "It's hard not to notice my work in a magazine," says a confident Brooks. "My goal is to create such a compelling image that it's almost impossible for you to ignore it."

Yet Brooks's hyper-vivid approach to editorial illustration is unique. Indeed, the

SUCCESS BEGINS WITH A DREAM.

SMALL FISH, SMALL DOTS Graphically succinct, Steve Bjorkman's humorous illustrations are marvelous studies in carefree spontaneity. Bjorkman is extremely adept at speaking volumes with a visual language.

vast majority of the nation's top humorous illustrators may share Brooks's desire to create imagery that stops readers in their tracks, but they accomplish the goal in more subtle ways.

Steve Bjorkman, for example, remains fascinated that he can coax a reader into an article with a wry piece of art. "The smallest twitch of a line can make a huge difference in how an illustration comes out," he says. "I am still amazed at how the smallest dot can impact the success of one of my drawings. Cartooning and humorous illustration is almost a language we use to communicate with readers."

Born auspiciously in the front seat of a 1949 Ford convertible, you'd expect Bjorkman to have a strange, if not twisted, view of life, yet his illustrations possess an almost sedate, understated level of humorous emotion. "People have commented that my illustrations appear somewhat lyrical," says Bjorkman, "but I think they're better described as whimsical. I really enjoy conveying some sense of emotion—whether it's sorrow, anger or joy. What I like best is conveying that humorous emotional content in a subtle way."

NOW BUY THIS!

And while humorous illustration is used often for applications in print advertising, its purpose there is more expansive than for editorial applications. Initially, a humorous illustration in an advertisement is intended to attract the attention of a reader and engage them to read the ad copy. But then the cumulative package is intended to prod the reader to buy the goods and services that it advertises.

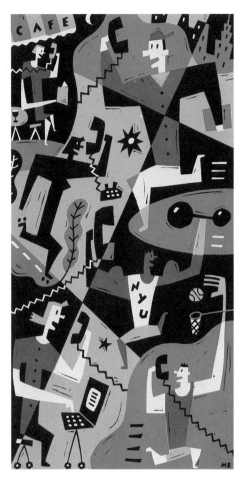

PHONE U! Michael Bartalos' high-impact, boldly hip humorous illustration adorns a postcard advertising NYU's "phone from home" registration program.

Humorous illustration is also often used on a variety of packaging, and here the illustration must compete with dozens of choices that vie for the attention of the buyer. One can see no better example of this than by browsing the cereal aisle at your local supermarket. While shoppers may have consistent cereal preferences, this does not stop the cereal industry from emblazoning the fronts, sides, backs and even bottoms of their packaging with photographs, attention-getting type treatments, straight illustrations, cartoon characters and, of course, humorous illustrations that (figuratively) scream to be picked up.

BIG KIWIS ARE AL-WAYS SUBTLE To illustrate an article in *BIZ* magazine about Australia's Kiwi Airlines, this idea seemed to be a natural. While the humor of the idea and the art don't hit you over the head like a ton of bricks, there's a certain subtle anxiety in the art that works.

Faced with ten or more brands of a pre-sweetened oat cereal from which to choose, often it's the free premium inside or the back panel game that prompts a buyer to purchase that particular box, and even before a cereal box promotion hits the shelves, it has undergone extensive test marketing to "focus groups" comprised of potential buyers. Such testing costs major cereal companies millions of dollars each year, but the costs are minor compared to profits.

But war takes place not only in the cereal aisle of your supermarket. Snack foods, ice cream products, fruit snacks, crackers, cookies, potato chips and sodas all battle for their share of the market by employing packaging illustration that is, predominantly, of a humorous nature.

Humorous illustration for greeting cards works the same way that it does for advertising. Like cereal, most greeting card buyers are already convinced to buy *a* card—the decision now is *which one*. Therefore, it is the humorous illustration and the humorous copy that must work symbiotically to sell the card.

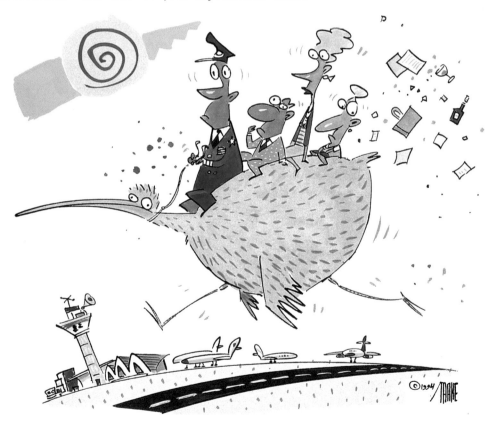

STYLE

FINDING A DISTINCT STYLE

If humorous illustration has reached its greatest level of prominence as a communicative tool, the dizzying diversity of drawing styles employed by the nation's top humorous illustrators is a primary reason for the form's increased popularity.

A simple flip through this book will reveal a multitude of styles ranging from the subtle to the graphic. This broad variety of styles is the best testimony to the healthy state of humorous illustration, and substantiates that where there's a style, there's usually an application for it.

Yet settling into a style can be unsettling at best, and to develop a stylistic identity, the artist must appreciate that while *any* style can be viewed as viable in the eyes of a humorous illustrator, the trick is ensuring that the style is popularly received and has application in the marketplace. After all, it doesn't matter if a humorous illustrator has a style if he isn't receiving assignments. It would be like having a shiny red Porsche—up on blocks in the garage.

Internationally-renowned for infusing his humorous illustrations with a delightful level of class and sophistication, Steven Guarnaccia offers a rude noisemaker as a metaphor to explain the viability of different stylistic approaches to humor.

"Humorous illustration always punctures convention and makes fun of things that are pretentious, conservative or stuffy. It's always like the whoopee cushion under the prig. Anyone can design the whoopee cushion. It can look like a wet rubber bag, or it can be this incredibly handcrafted, elegant item, yet it's still going to make the same sound."

Guarnaccia, highly successful with what is essentially an ink-line-filled-with-color humorous illustration approach, traces his stylistic influences to childhood—that period by which all humorous illustrators are subversively and signifi-

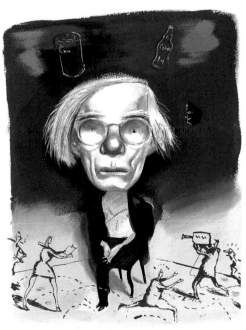

A DANDY ANDY The original Prince of Pop, Andy Warhol, is caricatured brilliantly by Everett Peck.

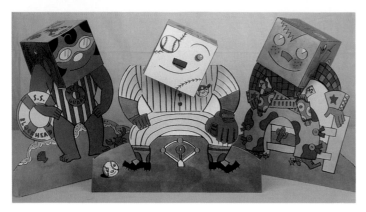

GUARNACCIA'S SQUARE DEAL Inspired by a French advertising counter display from the 1920s, Steve Guarnaccia created "Blockheads" for Children's Universe, because, as he so aptly puts it, "six heads are better than one." Guarnaccia's style was highly influenced by his childhood love of old comics.

cantly influenced, only to realize the fact much later in life. "I was really influenced by those Saturday morning animated cartoons of the 1940s that they'd rerun in the 1950s," says Guarnaccia. "You know, all that great Warner Brothers animation. I was also greatly influenced by *MAD*, particularly people like Don Martin, Paul Coker Jr., Will Elder and Jack Davis. But rather than choosing one source to be inspired by, I feel that there is a little of each of those influences in my work, although I'm trying to create something of my own. But it has been a long, long struggle to finally create a distinct style and get away with it."

By blending, both consciously and unconsciously, a wide variety of visual influences, Guarnaccia has developed one of the most instantly recognizible styles not only in humorous illustration, but in the even bigger world of illustration and design.

THE RIGHT ILLUSTRATOR FOR THE PROJECT

With a seemingly endless variety of humorous styles available, art directors can better assign a specific project to a humor-

ous illustrator whose style complements, meshes with, or, ideally, enhances the project itself. Humorous illustration, after all, is best utilized when the artwork co-exists symbiotically with advertising copy, a manuscript, or even emblazoned on packaging, and certain visual styles work better than others to accomplish certain communicative objectives.

For example, Elwood H. Smith's light-hearted, perky style is ideally suited to a project calling for silly cartoonish characters on a children's menu/placemat for a fast food chain, while Arnold Roth would probably never be considered for such a job mainly because his style (as wonderful as it is) wouldn't jibe as well in this particular application. Likewise, it's difficult to imagine Patrick McDonnell's understated, lyrical humorous illustration style being applied to a billboard campaign for potato chips, while it's easy to see why a client would want to employ Gary Baseman's graphically bold, in-your-face style for just such an application.

This is not to say that a number of different humorous illustration styles couldn't effectively be applied to the same project—they can. Given the assignment to illustrate a magazine article on the boom in frozen yogurt sales, David Sheldon, Peter de Sève and David Cowles could all illustrate the manuscript more than adequately, with no one necessarily better suited to the task than the other. But given a bevy of humorous illustration styles from which to choose, an art director may make the determination that Peter de Sève's breathy watercolor style should be used instead of Cowles's adventurously graphic approach or Sheldon's retro-based "cartoony" style.

In the end, most art directors will give the assignment to the artist whose style best fits into the general look and attitude of the magazine, and since a plethora of trade and consumer magazines exist in the marketplace, humorous illustrators have never before been afforded so many potential forums (one-time or ongoing) for their work.

UNDER THE INFLUENCE

Yet style doesn't just spontaneously appear like a UFO above a trailer park. If it is relatively easy to visually differentiate between one humorous illustrator and another simply by looking at their styles, it takes the humorous illustrator many years of experimentation, assignments and self-training before their style evolves into what ideally becomes a "trademark look."

If my work has developed a certain "style," it's because over the years I have allowed my drawings (as well as creative thought processes) to consciously and even subconsciously become influenced and inspired by other traditional and non-traditional artistic works. As a child, I was enthralled by "Huckleberry Hound," "Mr. Magoo" and animated commercials hyping everything from Malt-O-Meal to Eisenhower. As a teen, I was fascinated with the sheer poetry of professional football and devoured *MAD* magazine as if it were a visual candy bar, gorging myself on Mort Drucker's stunning ability as a caricaturist and studying Jack Davis cartoons as if I would later be tested on their content. In the late 1970s, my political cartoons at USC were inevitably influenced by such masters as Jeff MacNelly, Mike Peters and Pat Oliphant.

OLD ART? ELWOOD'S GOT IT! Lighthearted and perky, Elwood Smith's humorous illustration style couldn't be better suited for kid-oriented projects.

Today, my style seems to be a healthy amalgam of varied influences, and if I've been successful at letting my own distinct humorous illustration style emerge, I think it's because I have allowed myself to be inspired by things other than how another humorous illustrator may draw a rocket ship or how someone else may paint the detail of wood grain. After all, I already *know* how to draw rocket ships and can mix up the proper color of paint to adequately represent a pastiche of grain on a plank of pine, so I'm more interested in growing creatively as a humorous illustrator by allowing myself to remain influenced by a broader, more subversive, aesthetic.

For example, I love the biomorphic shapes and motifs of the 1950s, so imagery from that era continually surfaces in my scenes. Likewise, I can appreciate everything from an idealized purple cast shadow of a New Mexican mesa to the kinetic appeal of a zig zag. I like sans serif typefaces, red water towers atop urban

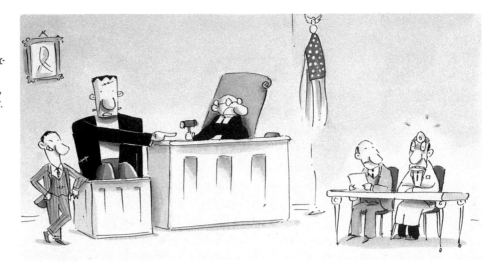

HE'S THE ONE WHO GAVE ME THE DEFECTIVE BRAIN! To illustrate an article on medical malpractice, Patrick McDonnell uses Frankenstein as a metaphor, or at least a reference point.

apartment buildings, and the color of pistachio ice cream. Although that may sound like a personal ad (SWM seeks DWF who likes lavender and futura bold) today *these* are the things that creep into my work (in big or small ways) and help define my style.

It's important for humorous illustrators, particularly young ones, to broaden their definition of what sort of things can be construed as stylistically influential. By doing this, a humorous illustrator is then better able to integrate imagery into his work that is fresh and unique and ultimately becomes important in creating a new, original aesthetic. Instead of studying how Gary Baseman draws eyeballs or

how Elwood H. Smith draws a grumpy dog, and then invoking those lessons learned, a humorous illustrator should creatively provoke himself with non-traditional sources for stylistic inspiration.

THIEVES AT THE DRAWING BOARD

Peter de Sève's whimsical humorous illustration style is likewise the result of a wide variety of graphic influences—from the expressive images of Heinrich Kley to the stunning ink drawings of A.B. Frost, and there are even detectable elements of Honore Daumier and Norman Rockwell in his work. Like most humorous illustrators, de Sève has allowed himself to be *inspired* by the work of others, but chides illustrators—humorous or not—who make the conscious effort to essentially "steal" a style.

De Sève himself is very often the victim of theft. A casual perusal of almost any illustration directory will reveal works by several illustrators who shamelessly imitate everything from de Sève's pen line, to the manner in which he applies successive

THEM MESAS IZ FUN TO DRAW AND SO ARE THEM CACTUSES The longer I draw, the more deadlines I have, the busier I become, then the absolute *last* thing on my mind is my style. It's just something that I have absolutely no time for. Once you get into that mind-set and relax, honest style seems to naturally develop.

washes of watercolor. To be sure, it's a white collar crime, this stylistic plagiarism, but as humorous illustration becomes more popular, so does stylistic thievery.

"A lot of humorous illustrators see a style that is successful," says de Sève, "and they decide they'll cash in by copying it. I can always tell the difference between the originator of the style, and the one who's copying it. It's important that a humorous illustrator allow his style to evolve naturally based on the things that he loves and admires rather than just imitating what someone else has been successful with."

What's particularly frightening is the blatant manner in which some aspiring humorous illustrators will attempt to absorb a popular graphic style, often with the encouragement of an art professor. In a recent *Communication Arts* story by Jeff Seaver, de Sève tells of a phone call he received from an art student who began asking very *specific* questions regarding his illustration technique. Piqued by her technical questions, de Sève asked the young woman why she wanted to know such specific details regarding his technique. She explained to de Sève that her illustration professor told his students to "break in" to illustration by doing exact imitations of other well-known illustrators' styles and then promoting that work.

Mike Lester, a Georgia-based humorous illustrator best known for his spontaneously carefree style, has increasingly found himself emulated by a battery of artists who have unabashedly chosen to steal significant chunks of his style, or even the entire enchilada.

"You're really no good," Lester says sarcastically, "unless you have two or

three guys doing imitations of your style. That's probably a terrible thing to say, but I have to look at the funny aspect of the situation or I'll get p----- off about it. I think Ralph Waldo Emerson best defined style in 1942 when he said that 'a man's style is his mind's voice.' You'll always have a style in you, it's just whether or not you have the balls to exhibit it."

Surprisingly, Robert de Michiell's work is regularly confused with Robert Risko's work. Look past the fact that de Michiell and Risko work in wholly different mediums (de Michiell prefers gouache while Risko's tool of choice is the airbrush), both humorous illustrator/caricaturists share an appreciation for the 1920s-era work of Miguel Covarrubias, Al Hirschfeld's graphically derivative tempera paintings, as well as other Jazz Age, Art Deco and Modernist visuals.

Anyone who confuses the two isn't looking very closely, but any bewilderment might be explained given that both humorous illustrators are often commis-

sioned by the same magazines—and often published in the same issues.

"I know exactly where I am on the list of humorous illustrators," de Michiell offers frankly, "and I know if they called Robert Risko and he turned it down, I'm the next person that they call. Some people still mistake my work for his and it's my pet peeve. People perceive that there's a rivalry between us. I also don't think it's applicable that my work is mistaken for David Cowles work. My work is more whimsical."

Risko is well aware of the confusion surrounding his work and de Michiell's. "He (de Michiell) is annoyed," says Risko, "that people are comparing him to me. He wants his work to be judged on its own merits. I've also heard that he says that my work is done in airbrush, and that his is done by hand or something. I think de Michiell goes back and forth being influenced by me and David Cowles."

But to confuse Risko, de Michiell *and* Cowles, all phenomenally talented humorous illustrators who all happen to focus on caricature, requires a certain leap—as well as fogged glasses. Cowles too is admittedly influenced by the same era artists as de Michiell and Risko, yet the respective styles of all three should appear distinct enough, if properly studied.

"For me," says Cowles, "style is something that sets a drawing apart from the norm. When you notice someone's style, it's because the illustration is doing something besides just doing the bare communication needs. It's going beyond, it's pushing things in a new direction. I mean, there are obviously humorous illustrators who have drawing styles that enable you to recognize their illustrations immedi-

ately. Al Hirschfeld is a great example of that. What he illustrates is almost secondary to his style. You really just look at the way he draws the hair, or the simplicity that he uses to draw a nose. That's style for me."

Primarily known for his singular celebrity caricatures in *Entertainment Weekly*, Cowles's stylistic approach to caricature is graphically stunning, and reflects his understanding of cubism. If Picasso were a caricaturist, he'd be David Cowles. Yet when Cowles is faced with the task of illustrating a *scene* involving more than a token celebrity, he readily relies on Covarrubias as the foundation of his stylistic presentation.

"When I humorously illustrate a scene," admits Cowles, "I lean on Covarrubias more than anyone else. I noticed that I started stealing everything from the guy's style as soon as I saw his work. So whenever I have an art director assigning a scene to me, I do tend to think of how Covarrubias would do the illustration."

EVERYTHING OLD IS NEW AGAIN

Greatly influenced in the beginning of his career by the 1930s-era comic artwork of Billy DeBeck, George Herriman and Rube Goldberg, today Elwood H. Smith's 1990s pen and ink style reveals less and less of these influences. Today, Smith's hybrid style is arguably the most recognizable in contemporary humorous illustration.

As Smith was assigned more and more high-profile editorial and advertising work in the 1980s, he greatly legitimized humorous illustration as *design*—not merely

slapstick doodlery. Prior to Smith's mid-1980s burst, humorous illustration was infrequently employed by art directors with any sophistication, and when it was employed, it was usually drawn by Jack Davis.

Nonetheless, if you think that Smith was able to develop his seemingly carefree style without breaking a sweat, guess again. "I've met humorous illustrators," says Smith, "who came full-fledged into the world with a style, but I didn't. Some people just draw and it comes out very naturally, but for me it's always been hard work. It's getting easier, though."

"As a kid," recalls Smith, "I used to read *Barney Google*, *Krazy Kat*, *Mutt 'n' Jeff* and *Pogo*. Years later, my influences were more cerebral—Seymour Chwast, Ed Sorel, Milton Glaser—more design-oriented, less cartoony, a little more heady. I even went through a period where I looked a little like Alan E. Cober and R.O. Blechman put in a blender."

What's fascinating about the evolution of Smith's style is that it was originally based on the "big foot" graphics of dead cartoonists, was modified through the years, finally became a hybrid in its own right, and in a full circle, is now being copied by a whole generation of humorous illustrators, most of them unable to even name Krazy Kat's love interest (Ignatz the Mouse, of course).

Smith now finds himself in the unique position of being victimized by a handful of humorous illustrators happy to replicate his style in order to make a living. And to add insult to injury, some of these clones are snagging lucrative, high profile work.

"It took me so long to develop my style," says Smith, "and I used to wonder if I would be magnanimous if people started imitating me. Now I see people using my graphic treatments and basically the same or very similar characters, and I don't look kindly upon it. For example, currently there's a billboard campaign in New York that I've received a lot of complimentary comments about, but it's not my work. It's just this guy imitating me!"

Representing Elwood H. Smith as one of the illustrators in the Push Pin Group in the early 1980s, Seymour Chwast is well aware of how Smith's trademark style evolved. "I know that today Elwood has a lot of imitators," says Chwast, "but on the other hand, he derived his style from *Barney Google*. His style then evolved to what he's doing now and it's very revolutionary. I love Elwood's work, and it's a shame that people are imitating his style. If you're imitating a (living) humorous illustrator now, it doesn't make much sense, especially if you're not changing anything or adding anything new."

COOL CRIMINALS

Seeing himself as more of a designer than a humorous illustrator, Seymour Chwast theorizes that when younger humorous illustrators make a conscious effort to swipe a style, they do so because they've been able to recognize what's cool.

"People always respond to different styles," says Chwast, "depending on whether it's cool at the time. Right now there are a lot of illustrators working in a sort of primitive style. If people like that look and see that it has become cool, then others are bound to imitate it. I used to work in a style that was achieved with unconnected lines, but then a lot of other

illustrators started to imitate the look so I had to give it up. I just started connecting my lines again. Styles are generally just things that are applied to one's work and are simply embellishments."

Placing an inordinate amount of importance on style, Lou Brooks agrees, is simply a part of being young. "I think when you're starting out as a humorous illustrator you're obsessed with style, not just within your art, but in your life," says Brooks. "You want to be the hot s---. You see how other people look, how they dress and how they paint. You see things in terms of what's cool, and everyone wants to be cool. For every top humorous illustrator, I think you have three or five people who rip off their style."

A casual perusal through any illustration directory—from *American Showcase* to *RSVP*—will make you wonder if Jack Davis was kidnapped and used in some sort of weird, government cloning experiments off the coast of Georgia. You would think that stealing Davis's unparalleled, signature humorous illustration would be creative suicide, but this hasn't dissuaded a handful of imitators.

Davis is genuinely flattered by the imitators, but wonders what the point is. "Sometimes I see work and think, my God, that guy draws just like I do!" laughs Davis. "I accept it as a compliment, but if these (imitative) humorous illustrators expect to be a success later in life, they're just wasting their time and spinning their wheels by copying my work. When someone continues to copy, they never improve. You need to be honest in your work."

WHERE THERE'S A THIEF, THERE'S WORK

For a period from the 1960s through the mid-1970s, Davis created a substantial amount of lucrative humorous illustration used on movie posters, but slowly that work began to dry up. "I think what happened in Hollywood," Davis assumes, "was that they could find someone who could draw these movie posters just the way I would, only cheaper. You can't blame them, I guess, because that's business."

Nevertheless, blatantly imitative humorous illustrators wouldn't get work were it not for the art directors who choose to hire them. "I've talked with art directors who hire imitative humorous illustrators," says Elwood H. Smith, "and they think that if a known humorous illustrator is too busy or expensive, then they have the right to get someone who works in a similar style. That seems damned unfair to me. My argument would be that they should instead find someone who is perhaps similar in their humorous approach, but not a stylistic imitator. So if an art director couldn't get me, then why not use Patrick McDonnell, or someone like that."

However Chwast feels that art directors aren't to blame. "When art directors hire a humorous illustrator," says Chwast, "they're only doing their job. I don't think there's any loss of integrity on an art director's part when he or she hires an illustrator who's imitative. But the loss of integrity may be on the part of the humorous illustrator."

FROM WHALE TANKS TO WINE

For a humorous illustrator to evolve a style that is honest, unique and ultimately marketable, nothing is more important than time. After all, it only takes a couple hours to concoct enough Coca-Cola to fill a whale tank at Sea World, while it can take a couple decades to age a single bottle of bordeaux. Good things take time.

The evolution of Gary Baseman's style best illustrates the point. While today he is unquestionably regarded as one of the nation's most successful, high-profile humorous illustrators, Baseman's style wasn't always so well-received. Fresh out of UCLA in 1982, Baseman made a trip to New York to show his portfolio to two of his "illustration idols." In the morning he showed his portfolio to R.O. Blechman, and later that afternoon had an appointment to show his work to Edward Sorel, an institution in illustration and caricature, yet widely regarded as a curmudgeon of sorts.

"Blechman just loved my stuff," recalls Baseman, "he said my style was wonderful and that it was really art. Then I saw Sorel. He said, 'I don't get it, you should go back to art school. You should go back to Los Angeles and study under some car toonist and take their style. I don't know, maybe I'm getting old, but I just don't like it'."

A flurry of emotions swelled up in Baseman. "I was p-----, I was depressed, but it didn't stop me from showing my portfolio," Baseman says. "I don't think he was being mean, he was being honest, but if a young humorous illustrator came to me with his work, I wouldn't be that abrupt. I think I'd try to help them in a positive way."

A couple years later, Baseman was at a Manhattan film house having transparencies of his work made, and Sorel happened to be standing next to him. Seeing Baseman's work, Sorel leaned over and asked "Are you Gary Baseman?" Baseman replied he was. "I've been seeing your work all over the place," Sorel continued, "It's really great."

Baseman doesn't share the story out of any bitterness, and he has nothing but positive feelings about Sorel, whom he's sure didn't remember that younger Baseman who visited his studio. Yet Baseman's story speaks volumes about perseverance, artistic tenacity and the patience required for a trademark style to evolve.

Baseman says the day he showed his portfolio to Sorel, "I decided not to see any more humorous illustrators. I'm going to see art directors who can hire me and help my style grow."

THE SKINNY ON GREEN While Gary Baseman views his pastel humorous illustration style to be very safe ("it's sugar-coated soda pop, but it's good soda pop"), his preference is to color the skin tones of his characters anything but flesh-toned. In Baseman's work, red faces are common, blue ones are too, but green seems to be his color of choice.

MEDIUMS AND TECHNIQUES

THE OPTIONS ARE LIMITLESS

If there is more than one way to build a house, there are also limitless ways to create a humorous illustration. Some illustrators create inked infrastructures of lines that are then painted over with watercolor, while others utilize pigment-spewing airbrushes to generate their levity-laden scenes. An increasing number have merged onto the information superhighway, harnessing the power of the computer to aid them at the drawing board, while others are content to primordially squeeze, sculpt and mold clay to form their three-dimensional "illustrations."

If the field has never been infused with such a vast array of styles, it is partly because the humorous illustrator has never before been afforded so many media options. Humorous illustration, after all, can be created as effectively in a common pencil line, as it can when constructed as a papier-maché diorama.

Historically, humor-minded artists have always been open to experimenting with new and uncommon mediums. Al Hirschfeld would often employ household items such as steel wool and fabric swatches to create visually inventive caricatures of the Marx Brothers; Saul Steinberg would retouch photographs of pipes and turn them into Manhattan skyscrap-

ers. Today, humorous illustrators carry on this experimentation tradition. Steven Kroninger cuts up photos to create humorous collage art, David Cowles uses feathers, cardboard and craft store doodads to engender satirical likenesses of celebrities, and David Goldin employs antique labels and other printed ephemera which give his illustrations a refreshingly campy appeal.

CUTTING LOOSE FROM THE CASTLE Robert Risko caricatures Johnny Depp as Edward Scissorhands, Risko has long preferred using an airbrush to create his lush caricatures and humorous illustrations, although he will add sparse colored pencil highlights that accentuate textures, details or contrast.

DEFINING THE TERMS

In the context of humorous illustration, a "medium" can best be described as a type of material used for the purpose of creating art in the same way that a house can be built using the mediums of brick, wood or steel. In the end, each medium will produce a house, yet the final product will look decidedly different depending on the kind of material used.

"Technique," on the other hand, is not as easily defined. Dipping a pen nib into an ink medium leaves the artist to determine what technique to use to get the ink onto his paper. He can use the pen to *draw* the ink on with free-flowing sweeps of the hand, he can dot the ink in a *stipple* fashion, or even *spatter* the ink in blots by jerking his hand like a jackhammer. Each will produce very different results.

However, most humorous illustrators prefer to blend a number of mediums and techniques in their work to create a desirable graphic look.

ACCIDENTS CAN HAPPEN

I, for one, enjoy employing a pen technique that has a decidedly spontaneous appearance, and if all goes well, my pen line will even appear thicker and thinner at parts. To encourage this spontaneous pen line, I have essentially abandoned all pencilling of my drawings. I will draw a pencil sketch in rough form for my art director and myself to review, but when I create my final line art, the sketch serves as nothing more than a general map reminding me of where this character fits in, how this building should slant, or even

DON'T THROW AWAY THOSE TOILET PAPER ROLLS David Goldin uses a wide variety of printed ephemera in his illustrations.

where this dog should be hiding.

Once I have created the pen drawing of the final art, I will often redraw faces, better animate gestures, and even restage

OOPS! This is nothing more than a crisp, clean copy of my line art photocopied on drawing paper then painted. With this technique I can maintain the spontaneity that I love, but the line art doesn't look sloppy, a common side effect of art that is spontaneously generated.

THIS GUY IS NOTHING MORE THAN PHOTO-COPIED LINE ART ON COLORED PAPER By drawing the line art for this card very small, and blowing it up 225 percent onto different pieces of colored paper, all I needed to do was a little cutting and gluing to create this fun piece of greeting card art for Paramount Cards.

WHY EATING RAW SEAFOOD IS SUCH A BAD IDEA While Mike Lester's humorous illustration style appears wholly original, he's honest about his influences. There's a lot of Chuck Jones in my work," admits Lester, "I think we're *all* influenced by others, and that's just the way the arts are."

portions of my composition with which I am unhappy. I simply redraw these elements in pen, slice them out with an X-acto knife and adhere them over my main drawing. Naturally, with dozens of corrected elements adhered to my penned infrastucture, it would be virtually impossible to add color to the inkwork. This is why I then photocopy my pen drawing directly to a sheet of drawing paper and apply paint and colored pencil to a one hundred percent pristine, virginal sheet of paper.

Actually, I stumbled quite accidentally onto this combination of technique and medium in the late 1980s. I had just discovered a new pen (the disposable Fountain Pentel) that was able to create a de-

lightfully spontaneous line in thick and thin lines depending on what pressure I applied. After penning this wonderfully intricate, wildly zany scene, I began to add watercolor to the drawing and only then realized that Fountain Pentel ink is anything but permanent (most intelligent illustrators would determine this before adding wet paint).

Rather than scrap the pen drawing, I simply jammed it into the studio copier, inserted a piece of drawing paper, pushed a red button, and hoped for the best. When I painted on the paper, I was astounded at the results. I soon realized additional benefits. The pen lines, now reproduced in toner from the copier, even *repelled* the properly thinned watercolor thus maintaining their solid black quality. Furthermore, painting on a *copy* had a very liberating effect on how I colored the drawing. I could even spill anything from red Dr. Martin's dye to black Folgers on the art and simply recopy the drawing and start again.

Monday through Friday, five days a week, this is how I create my work, and I had always assumed this process to be my little technical secret. But it wasn't until I began doing research for this book that I discovered that a number of my colleagues employ the technique as well, and we're now all banding together to buy bulk stock in Xerox.

Mike Lester insists that he "runs that copier just as much" as I do. "It almost feels like cheating," says Lester, "but the copier is no less of a tool than airbrush. I don't use a pen to create my line art, instead I use a 3H pencil because it has the hardest lead that can give me the blackest line. I'll then photocopy the drawing any-

where from five to ten times until I get it right, but I'll usually shoot the art at 50% of the original size knowing it will then be blown up to 200% when it's reproduced."

LOTS O' WORK? LOTS O' EXPERIMENTATION

As the work load of any humorous illustrator increases, it is only natural to search for ways to increase productivity while retaining quality. Deluged one week in 1992 with a seemingly insurmountable load of eighteen to twenty assignments, I knew it would be impossible to draw line work for these assignments, let alone paint them, using my usual methods.

By looking at the assignments before me, I quickly concluded that a number of the pieces would need to be created using my above-mentioned photocopy/painting technique, and decided to experiment with the remaining assignments.

Five of these assignments were greeting cards, so I decided to draw the line art for these pieces quite small (perhaps 2" wide by 3½" tall) and then *enlarge* them as much as 225% in preparation of painting. I immediately responded to the graphically bold quality of the pen line and decided to take things a step further.

I then copied the blown-up line work onto ten pieces of ordinary, colored bond paper. After laying down the version of my line art copied onto blue paper, I then cut out elements of the art using the different colored paper copies (the red copy for flesh tones, chartreuse for a patch of grass, lavender for a distant mountain, etc.) and affixed them in a collage fashion with Spray Mount. This new technique enabled me to create these pieces in *less than*

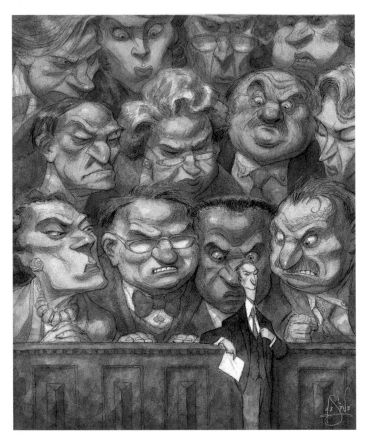

WHAT SAY YOU THE JURY? Are You Sketchy Enough? Always wishing to preserve the liveliness and spontaneity of his pencil sketches, Peter de Sève is able to maintain the sketchiness of his drawing by continually coloring it with successive layers of wash.

half the time it would normally take.

I had always prided myself on my ability to work fast and had doubted there was any way to speed up my already spontaneous technique, but by experimenting with new mediums and techniques, I've been able to discover an approach that art directors increasingly request me to use. Today, approximately twenty-five percent of my greeting card, magazine and some advertising work is created using this colored paper/photocopy technique.

THERE'S MORE THAN ONE WAY TO SKIN (OR PAINT) A CAT

Having primarily solitary workplaces with no real boss to answer to (unless you include the art director who's on the phone), it's no surprise that most humorous illustrators delight in possessing the power to select what they're going to draw with and how they're going to do it. Therefore, armed with a few preferences for mediums and an acquired technique or two along the way, almost every humorous illustrator sets down the path of creative self-determination.

Steve Guarnaccia creates by using a trademark pen technique that he fills in with a watercolor medium. "Essentially," says Guarnaccia, "my technique is one of filling in a flat line with color, which is the direct result of my love of comic books and animation. I was always taken by the flat colors that were laid into the drawings in the comic book departments. I wasn't trained as an artist, so I never really learned how to apply paint to a surface. In fact, during my first two years in New York City, I only did black-and-white work. I remember getting my first color job from *Sesame Street* magazine and having to ask a friend how to paint. Now I just tend to put down this color, this color and this color and hope that it looks good when it's done."

Peter de Sève also uses a watercolor medium, but uses it in a completely different manner than Guarnaccia. De Sève employs successive layering of watercolor washes to build an almost sculptural contrast in his illustrations clearly approaching his work in an almost classical, painterly fashion.

After doing a rough drawing, de Sève then works on his final painting "trying to desperately emulate what's in that sketch," he says. "That's because there's usually a truth in that sketch, so I rub it

down to my watercolor paper, I stretch the paper, pencil it some more, refine the drawing, and then start painting it lightly and building up the colors until I do the inking. I then paint some more and ink some more, and it goes back and forth like that until it's finished."

If watercolor is arguably the painting medium most commonly used by humorous illustrators, the application of the paint and the selection of a certain palette of colors can differ. "When I use watercolors," says Patrick McDonnell, "I prefer using pastels. If I use a yellow, it's more an ochre than a lemon yellow. I don't use very strong reds, instead my reds are also more on the pink or orange side. The way I use watercolors has just sort of evolved, and you tend to use colors that look nice to you."

MODIFYING TECHNIQUES TO SAVE TIME

Increasingly, Drew Friedman is forcing himself to experiment with ameliorations of his pen stipple technique. "Personally," Friedman bristles, "I despise the medium of stipple and hate the way people traditionally use it. When I look at stipple drawings I almost retch because it's a technique that most people use to draw clouds, curtains blowing in the breeze and crap like that. I just more or less stumbled on the technique because it worked well to show facial details."

But since Friedman has moved further away from the slower paced world of underground comics and into the frenetic arena of editorial humorous illustration, he

has almost been forced to abandon the labor-intensive stipple medium that made him famous.

"I'm getting away from stipple," Friedman explains, "because it's time-consuming. I still stipple when doing faces, but I also use more pencil shading, cross-hatching and gouache because it gives the art a fuller look. Now I have a lot more things going on in there. I work faster now that I'm not working strictly in stipple."

Friedman's experience demonstrates how non-artistic forces such as increased work load, tighter deadlines and even reproduction limitations require a humorous illustrator to alter his technique, while others remain firmly locked into techniques and mediums that they have comfortably used for most of their professional careers.

"When I started," says Steven Guarnaccia, "I was always interested in the line. I felt that all you really needed was a 0003 pen and a piece of paper and you could say everything you needed to say in the world. I hit on watercolor immediately, partly because it was quick, partly because it was the least messy medium. I just started using watercolor and I never looked back. I've experimented with other mediums (such as colored pencil on brown paper), but for three quarters of my career as a humorous illustrator, I've been applying watercolor with a Winsor & Newton brush to Fabriano paper."

THE BUCKS STOP HERE
For years having created his work in a dot-by-dot stipple technique, Drew Friedman has far from abandoned stipple, although for the sake of speed, he has also been incorporating other time-saving techniques like pencil shading, gouache painting and the use of more solid blacks.

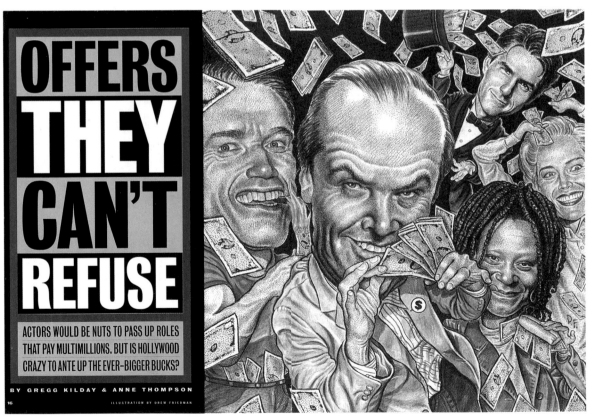

OFFERS THEY CAN'T REFUSE

ACTORS WOULD BE NUTS TO PASS UP ROLES THAT PAY MULTIMILLIONS. BUT IS HOLLYWOOD CRAZY TO ANTE UP THE EVER-BIGGER BUCKS?

BY GREGG KILDAY & ANNE THOMPSON

16 ILLUSTRATION BY DREW FRIEDMAN

BORED? THEN BYTE ME!

If boredom is the greatest contributing factor to malaise in a big law firm, a medium-sized factory, or a small accounting firm, it can also infiltrate a studio.

Known for a retro-based humorous illustration style evocative of 1950s animation, David Sheldon's preferred medium had always been gouache. "I always loved the creamy texture of gouache, but it began to bore me," says Sheldon. "With gouache, it could take me a day and a half to create a small spot illustration, and I got to the point where I'd have to turn down work that I *wanted* to do, but didn't have time for."

Today, Sheldon is one of a growing breed of illustrators who have embraced the computer as the most advanced creative medium since the fountain pen. Sheldon still draws his black-and-white line art by hand, but then scans the image into his computer where the art is colored on a screen.

"If you don't like a color," says Sheldon, "you just change it. You can also take the line art and flop it, turn it upside down, or even make a fat guy skinny. I can also enlarge or reduce different elements of the art. The one thing that I miss is the ability to add more textural color, but I've just started to use a computer program that will allow me to add more texture."

But if the manner in which Sheldon produces his art sounds futuristic, his method of delivering his illustrations to a client sounds like a scene from "The Jetsons." "Once the art's ready," says Sheldon, "I just use the phone line to modem the art directly to my client. It's something that's happening more often, and pretty soon Federal Express won't be delivering

art. But I'm sure that twenty years from now, people are going to tire of the computer look and clients will be demanding real painting again."

Mark Marek, long regarded as one of humorous illustration's most visually sophisticated practitioners, accurately predicted the advent of the computer as the new medium, yet he had no idea that he would use the tool to get *out* of humorous illustration. "I had anticipated," Marek said, "that the computer would enable one to run a home-based animation studio. Networks like *Nickelodeon* were looking for ways to create animation inexpensively, and my system can accomplish that."

After creating and animating June and Henry, host characters for *Nickelodeon*'s new show "Blam!" (best described as a "Liquid Television" for kids), Marek's computer is helping him redirect himself out of editorial humorous illustration and into animation. "Humorous illustration just started to become unpleasant," admits Marek. "Maybe in three years I'll find that animation is a total crock, but for now I'm finding turning down humorous illustration jobs to be a big relief."

"I got into computers," Marek continues, "because I wasn't making enough money as a humorous illustrator. When I stumbled on the computer, I thought, 'Gee, this is pretty fantastic—I'm just not going to turn away from this thing.' Computer animation is really a good avenue for a lot of humorous illustrators."

But not all humorous illustrators agree. In fact, many are skeptical of the computer as the ideal, new medium. "I think if they're used right, computers would be wonderful," says Bill Mayer. "But when you're working with a computer, you have

STICKING WITH GOUACHE David Cowles continues to create his flat planes of color with gouache, a water-soluble paint somewhat similar to tempera.

I GOT YOU, BABE Normally, I would have created a little more accurate caricature of Babe Ruth for *Kidsports* magazine, but I felt like I wanted to do something a little more fun. Therefore, this piece is almost an *anti-caricature*, in fact, it looks almost nothing like the Bambino, and the only clue that it is, is the number 3 on his jersey. Yet by loosening up a little and allowing mysef to have a little creative freedom with a fairly boring, mundane assignment, I think the result is a pleasing departure.

to make what *you* do fit what *they* do. Can you really imitate the freshness of a pencil line on a computer? What's the point?"

Nonetheless, humorous illustrations have almost *always* been created using tools that would seem intrinsically restrictive. Pencils, brushes and pens were basically designed to be used in certain, general ways, but a creative humorous illustrator can wield them to accomplish things they were never designed to do. Toothbrushes were made to hold Crest, but this hasn't stopped Robert de Michiell from loading his with goauche and then spattering his illustration board.

The computer, then, should only be viewed as but another in a long line of graphic tools with its own set of inherent limitations, best suited for a generation of humorous illustrators who can accept the challenge to push and stretch those limitations in order to create art previously unimagined. Only time will tell if we who have chosen to underestimate the power of the computer—or ignore it altogether—will come to regret it.

THE MEDIUM ISN'T THE MESSAGE

And while medium and technique are crucial elements in any humorous illustration, their importance should not be overstressed. Medium and technique, after all, are akin to the paint job on a car. They're the first things you notice, but in the bigger scope of things, are probably the least important.

"A lot of art students put too much emphasis on medium and technique," says Gary Baseman, "and that's where the problem is with art school. I've always felt that if you have trust, direction and confidence, that's ninety percent of humorous illustration or any other field. Technique and everything else then fits into what it is you're trying to create. Any good technician can do what I do better by using a different technique and materials, and they can do a much cleaner, stronger job. I've learned what I've learned by accident, experiment, trial and error, or just by screwing up. I'd rather emphasize why I create certain ideas, rather than why I create certain art."

Marek agrees that when a humorous illustrator places certain physical restrictions on himself, or forces himself to experiment in different mediums, he is better able to grow creatively.

"I've always enjoyed forcing myself to draw with my left (nondrawing) hand," says Marek, "and doing other things that physically alter the way I normally draw. I think most humorous illustrators would agree that it's a good idea to shift mediums, which in turn causes you to shift your brain waves."

"Forcing yourself into uncomfortable territory can ultimately pay back in a different style," he says. "Switching from a pen to pencil, or ink to a computer, doesn't detract from the work that you're doing, it only enhances it."

TWENTY MEDIUMS, TWENTY TECHNIQUES

It would surely require an additional two or three books to thoroughly discuss the arguably infinite number of techniques and mediums that one could employ to create any humorous illustration.

The following examples were created using the (arguably) more popular techniques and materials, yet they represent the mere tip of the iceberg in terms of what's possible.

'TOON IN, KIDS Mark Marek's animated "June and Henry" characters will introduce segments on Nickelodeon's "Blam!" which Marek describes as a "Liquid Television" for kids.

LET'S HOPE HE'S ON OUR SIDE Mark Marek has long experimented with various mediums and techniques which keeps his style in a constant state of evolution. "As far as mediums," says Marek, "you just go about your life and pick up what's thrown at you and use it."

2

Mediums: Watercolor and ink.
Technique: Watercolor wash
and inked pen line. *Illustrator:*
Steve Bjorkman

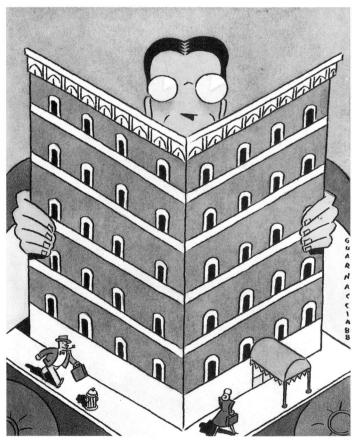

1

Mediums: Ink and Watercolor.
Technique: Consistently thick
pen line filled with pigment.
Illustrator: Steven Guarnaccia

3

Mediums: Airbrushed pigment, colored pencil. *Technique:* Solidized and graduated color using frisket. *Illustrator:* Robert Risko

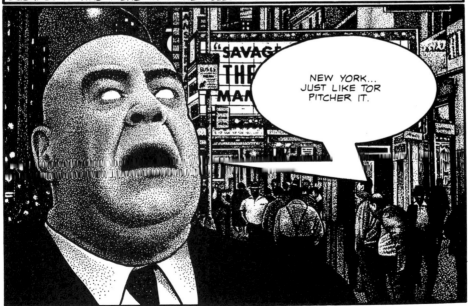

4

Mediums: Pen and ink. *Technique:* Stippled pen dots to create contrast. *Illustrator:* Drew Friedman

5

Mediums: Templates, french curves, colored film, spattered paint. *Technique:* Ink lines filled with bold, solid color. *Illustrator:* Lou Brooks

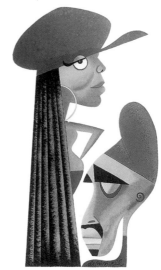

6

Medium: Gouache on illustration board. *Technique:* Distorted caricature using graduated, opaque coloration with wet or dry brush, toothbrush spatter and sponge. *Illustrator:* Robert de Michiell

7

Medium: Pen and Ink. *Technique:* Reiterated scratches with pen to create thickened or "doubled-up" line. *Illustrator:* Arnold Roth

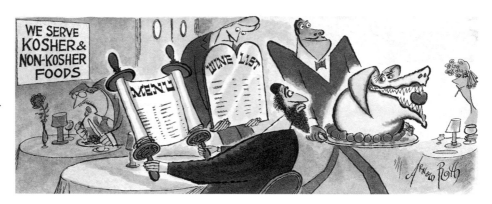

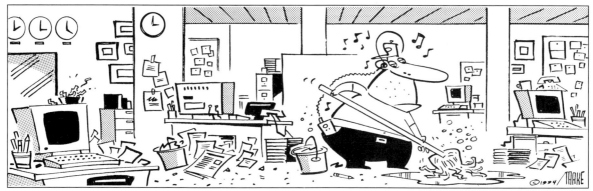

8

Medium: Pen and Ink with Zip-A-Tone. *Technique:* Spontaneously-generated, thick to thin pen line with mechanical gray tone. *Illustrator:* Bob Staake

9

Mediums: Pain, prescription labels, firecrackers, matches, and other found objects. *Technique:* Combination of elements to create 3-dimensional illustration. *Illustrator:* David Goldin

10

Medium: Colored clay. *Technique:* Sculptured scene. *Illustrator:* Richard McNeel

11

Medium: Collage and cut paper. *Technique:* Assemblage of cut papers. *Illustrator:* Tom R. Garrett

12

Medium: Colored photocopy. *Technique:* Photocopy painted with watercolor. *Illustrator:* Bob Staake

13

Medium: Pastel chalk and paint. *Technique:* Pastel rubbed into paper with opaque paint added primarily for highlights. *Illustrator:* Gary Baseman

14

Medium: Ink and colored pencil over colored paper. *Technique:* Nonwhite tone of paper provides foundation of color, ink line then filled in with opaque colored pencils. *Illustrator:* Steven Guarnaccia

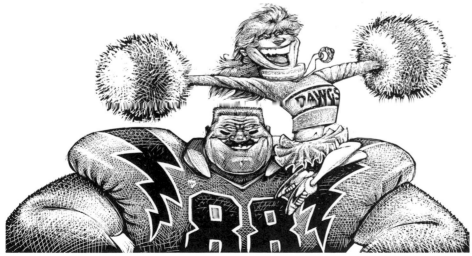

15

Medium: Scratchboard. *Technique:* Scraping away of scratchboard surface to create reversed image. *Illustrator:* Mike Lester

16

Medium: Acrylic paint on illustration board. *Technique:* Wet on dry application of paint. *Illustrator:* Ori Hofmekler

17

Medium: Humorous art created on computer. *Technique:* Line art created, then solidized color is added electronically. *Illustrator:* Robert Zimmerman

18

Medium: Pen and ink. *Technique:* Crosshatched pen line in varied density to create contrasting grays. *Illustrator:* Jeff Seaver

19

Mediums: Soft pencil with limited watercolor. *Technique:* Pencil used for outlining and shading with wash used to fill in solid shades. *Illustrator:* H.B. Lewis

20

Mediums: Brush, ink, watercolor. *Technique:* Brushed ink line with colored wash. *Illustrator:* Jack Davis

IDEAS, CONCEPTS AND BRAINSTORMS

SO WHAT'S THE BIG IDEA?

Certainly few people would deny the relevance of a humorous illustration's visual elements, yet the significance of the *ideas* behind a humorous illustration, particularly when editorial in nature, cannot be overemphasized.

An idea, after all, elevates a humorous illustration to a new dimension by cleverly weaving conceptual and visual components together to form a singular humorous statement. Ideas, truly clever ideas, give humorous illustrations added impact and remove them from being mere graphic representations of particular anecdotes found in a manuscript. However, in most discussions of illustration, precious little attention is paid to the notion of ideas and exactly where they come from.

Steven Guarnaccia's humorous illustrations, as visually extraordinary as they are, can be even better appreciated for their ideas which symbiotically fuse their graphics with some sort of conceptual metaphor. For example, Guarnaccia adds an additional dimension to his cover art for the book *Hot Air* by creating a microphone that visually "reads" as both a microphone *and* the novel's lead character—a remarkably simple concept, but surprisingly effective.

Seeing himself predominantly as an entertainer, Guarnaccia understands that strong visual ideas can almost entrance a reader. "When I first started out," says Guarnaccia, "I felt that my goal was to serve the text by illustrating it. Today, I'm much more interested in creating a drawing that has its own reason for being. I don't completely ignore the text, but what I like to do is come up with an idea that becomes a parallel image that can stand on its own."

"I guess in many ways," Guarnaccia continues, "I'm a symbolic humorous illustrator. I feel that if you combine this symbol with this symbol, you will evoke this certain idea. That's sort of similar to the way a political cartoonist uses symbols as a way to catalyze a reaction in the mind of the viewer."

FROZEN FOLKS The premise of this piece was that celebs who were once red hot are now cold blue. "I find that the best ideas," says Cowles, "come to me while I'm taking a shower. I'll usually think of a bad idea first, but then that usually leads to something else, which finally gets you to a good idea."

JUMP STARTING THE LIGHTBULB ABOVE THE HEAD

The process that a humorous illustrator can go through to create an idea is utterly fascinating, yet it requires that the artist possess certain conceptual skills and an ability to creatively brainstorm. Idea creation, after all, is really writing—it's simply that this form of writing is generally manifested conceptually, without the aid of words.

To engender ideas, humorous illustrators generally employ a standardized technique and thought process that enables them to create clever concepts. Usually, when he reads a manuscript, he envisions a myriad of images that could be used to formulate an idea that could cleverly sum up the article. If one were to illustrate an article on macho men who are anything but mechanically handy around the house, I suppose it would be natural to envision some dummy using a hammer backwards, or wielding a screwdriver as a hammer, or possibly even show the character making an effort to turn a screw with the claw end of a hammer. And those ideas only relate to a hammer.

By sketching, the humorous illustrator would have no problem engendering similarly witty concepts showing a klutz unable to use drills, saws and wrenches, or even taking a wholly different approach, perhaps a ridiculously simple drawing in which the character has installed a faucet that points upwards, rather than down. Through the process of doodling, these symbols and visual ideas suddenly manifest, or suggest completely new conceptual approaches for solving the problem.

However, when I'm in the midst of inventive brainstorming, it's rare that I'm ever aware of the *process* of creative thought that is quite obviously transpiring. Having done it for so long, and also owing to my early training as a political cartoonist, it really becomes second nature for me to read a manuscript and imagine the ways to convey nonvisual concepts as tangible graphic features. Yet throughout this brainstorming, it's inevitable I quickly determine that some ideas work better than others. In fact, it's often the inferior ideas that somehow engender a wholly improved idea, and the creative thought process can produce a limitless number of ideas that are refined, ameliorated, accepted or abandoned.

Yet the ability to *think* in this manner requires that the humorous illustrator be able to call on a broad vocabulary of knowledge, not merely his technical ability to draw a funny picture. Therefore, I have always been interested in embracing a large amount of information, both visual and mental, which can invariably be applied to my illustrations. Indeed, a solid, general knowledge is an appreciable commodity that substantially aids the humorous illustrator in the creation of insightful, clever or well-reasoned ideas.

GREAT IDEAS REQUIRE GOING TO GREAT LENGTHS

Gary Baseman has been known to go to great lengths to sell his ideas to an editor or art director, particularly when he makes the assumption that they will resist it. Hired recently by *The Atlantic* to illustrate a humorous article on that special brand

creating work in acrylic. Incorporating elements of humor with serious imagery (he's used acrylics to illustrate articles on peptic ulcers and snoring), in many ways, Baseman seems to be reinventing himself, yet his creative exploration is a direct result of his acute interest in ideas over art.

And while Baseman claims that if he had a choice, he'd want to work in acrylics, he has the luxury of employing that approach or his pastel stratagem—whichever he deems best to illustrate his creative ideas.

WITH THREE YOU GET EGG ROLL

"Once upon a time," says Guarnaccia, "I used to use a sort of Chinese menu approach to creating concepts and ideas. Just as a hypothetical example, if I were to illustrate an article on water conservation and its impact on Native American land, I would create a list for 'water conservation' and list all the visual references to water that I could—from a spigot to a camel, an oasis to a pipe system. Then under a list entitled 'Native American,' I would put things like tepee, smoke signals, cactus, desert, Navajo rug, etc.

"Somehow an image from column A would then reverberate from column B," says Guarnaccia. "Perhaps the abstract pattern on the Navajo rug would become a pipe system, or the tepee would become a water tower. But basically what I would try to do is come up with a new image based on the combination of two otherwise unrelated images. We all hit on ones that are the ultimate clichés that everyone has used before, so you try to come up with fresh ones."

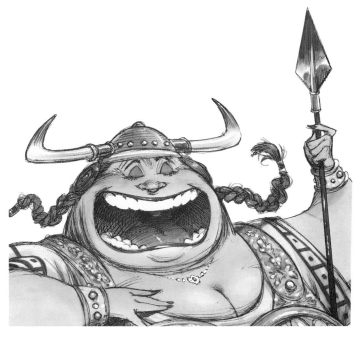

THE "SVELTE-CHALLENGED" LADY SINGS Lester calls on his memory when creating characters, but he also makes use of photographic reference. "I religiously keep a morgue," says Lester, "of women's fashions and women's clothes because styles change so rapidly, it's hard to keep up."

OODLES O' DOODLES As this page from his sketchbook shows, Steven Guarnaccia is a consummate doodler. "Today," says Guarnaccia, "there's this whole new generation of illustrators who seem to be much more artists than illustrators. I love hearing them say 'I turned down designing a new can for a Coke product because I had to get my kid's book done right' because it's so unlike me."

of cynical roughness exhibited by entertainers like Howard Stern and David Letterman, Baseman wanted to illustrate the article in an unusual manner.

"I had this really great idea," says Baseman, "to do my sketches on a yellow legal pad in colored pencil, because I wanted a sort of roughness in the art. The art director loved the sketches, but he was a little wary that the editor wouldn't go for that look in my finished illustration. But just in case the editor didn't go for it, I did the art twice. One version was done in my normal pastel approach and it looked kind of nice, but the other one was just drawn on notebook paper. In the end, they did go with the notebook paper approach, but I had to do two versions of everything, so sometimes I'm willing to make my life twice as difficult to sell my idea."

Conceptually, Baseman's work has come to include a certain duality. While he's best known for his "safe," cartoony pastel approach, Baseman has also been

Patrick McDonnell essentially uses the same approach to create his whimsical ideas, although in a less formalized manner. To illustrate a *Forbes* cover story on the seemingly nonhumorous topic of human organ transplants, McDonnell approached the assignment from three different conceptual perspectives, each progressively funnier than the last, yet all twists on the same theme.

When it comes to creating ideas, McDonnell has been fortunate to work with magazines that have afforded him a considerable amount of latitude. "I've been pretty lucky," he says, "and with some magazines, I don't even show them a sketch of my idea, I just send them the finished art. But when I do sketch out my ideas, I've learned that if I sketch out four ideas and only like two, I only fax them

the two. That's because, nine out of ten times, the art director will select the worst one."

Indeed, one of the most important lessons a humorous illustrator can learn is to *pro-actively* determine what he will ultimately draw by only submitting ideas that he's interested in completing. While I thoroughly enjoy creating ideas and could spend endless time and energy concocting six, seven or even eight ideas for any given manuscript, a busy work schedule pretty much limits me to envisioning one or two idea approaches that I then fax to an art director for his approval. Furthermore, I'm confident in my ability to quickly "hit" on a workable idea early into the manuscript, so grinding out four, five or six additional conceptual approaches tends to be redundant and unnecessary.

THE DIRECTION OF IDEA

Yet occasionally, an art director will offer an idea to a humorous illustrator that is generally the byproduct of a meeting between himself, an editor, and anyone else who might fill out a committee.

"When people call me up," says Peter de Sève, "and they say 'we've got this really funny idea,' the problem is usually that *their* idea of what's funny isn't *my* idea of what's funny, and I need to be able to tell jokes my way. I'll listen to what their ideas are, but I'd really rather think about it myself and see if I can approach an idea from my perspective and do something that is truly me."

"Unfortunately when it comes to advertising," continues de Sève, "humorous illustrators have little latitude with their ideas because they've been pre-sold to a

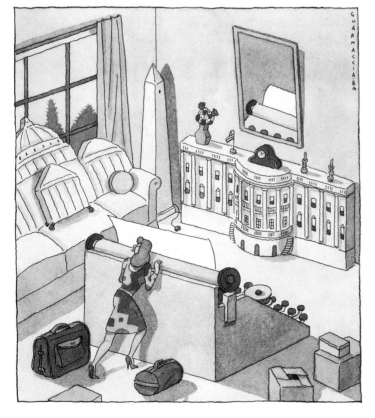

REDECORATE? A CAPITOL IDEA! Which are stronger? Steven Guarnaccia's graphics, or Steven Guarnaccia's ideas? Tough to say, yet Guarnaccia is at his best when his visuals work *symbiotically* with his ideas, as they do in this wonderfully inventive illustration.

client by an art director even before they got in touch with me. But with editorial work, I come up with the ideas for ninety-nine percent of my assignments. They just fax me the article and they're delighted with what I come up with. I always appreciate that, because if they supply me with the idea, I feel like they're only getting half their money's worth. I'm not saying that I haven't taken ideas that have been suggested to me, but very often I don't."

De Sève also refrains from illustrating anecdotes within a manuscript because he feels doing so requires little creativity. "The anecdotal approach," says de Sève, "is redundant because the anecdote is already in the manuscript. By illustrating the anecdote, you're only illustrating the author's punch line. Ideally, I want to bring a totally independent comment to the manuscript."

TAKING THE ANECDOTE

Creating an idea that essentially illustrates a specific anecdote in a manuscript may be the most common conceptual stratagem employed by humorous illustrators, yet some would view this approach as inherently, well, lazy.

That assessment, of course, is totally ridiculous, and if a humorous illustrator believes that his first and foremost goal is to create a compelling piece of humorous art to pull a reader into a manuscript, then it would tend to reason that it is unimportant if the art illustrates a specific point in the article or is based on a "higher" concept or idea.

Robert de Michiell is expert at this, and his boldly composed humorous illustra-

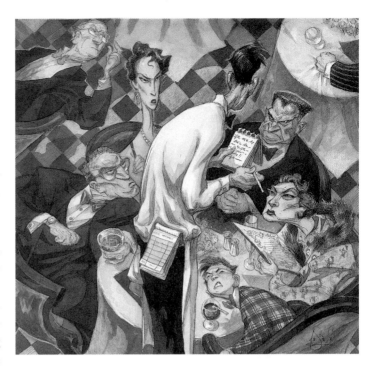

tions are anything but avoidable. "I definitely illustrate from an anecdotal point of view," says Robert de Michiell. "You know, the kind of story where someone went to Spain on their vacation and got robbed while they were sleeping. I then take that idea and push it as far as I can and have fun with the setting or the type of characters that are specifically mentioned in the story. When it comes to the 'high concept' illustration that people like David Suter and Brian Cronin create where this big hand represents government and this little building represents something else, I don't think I'm particularly good at coming up with those allegories."

Indeed, when de Michiell humorously illustrates an article in *American Health* suggesting that women "bone up" on calcium, he is illustrating specific anecdotal points within the manuscript, yet the illustration stands on its own as a consummate

TOUGH CROWD By using an elevated point of view and staging his scene in a manner not unlike Norman Rockwell, Peter de Sève injects a tremendous amount of drama and tension into this restaurant scene.

statement of the *entire* article. In fact, one could merely look at de Michiell's art and easily make the connection that (a) women need (b) milk, cheese and vitamin D for (c) strong bones. With illustrations like that, who needs writers?

Jack Davis also relies heavily on specified imagery within a manuscript as a source of conceptual inspiration, and when he alludes to a point in an article, you can be assured that the drawing will contain an overkill of humorous slapstick. "I look at a manuscript," says Davis, "and all of a sudden my mind starts to wander. I figure out what's funny, what I'd like to draw, and ideas start to pop in my head. . . . I look at something that's a little humorous and then I exaggerate it."

While Elwood H. Smith insists that his process of working is "a little anal" and requires that he spend time gathering up reference pictures if he were called on to draw everything from a donkey to a steamroller, he is able to generate ideas fast. "If you asked me to draw a donkey right now," admits Smith, "I'd have to pull out a reference photo. And if I had to draw a steamroller, I don't know if the big wheel is in the front or in the back. I'm just not fast that way."

"But one of the things I'm fast at,"

Smith continues, "is the creation of ideas. I sit down to read the manuscript and as I'm reading it, ideas start popping up. Sometimes I'll make little thumbnail doodles in the margins of the manuscript that are nothing but stick figures."

Yet occasionally, Smith is contacted to illustrate a manuscript that is in the process of being written, so the manuscript is unavailable to him. "Once in a while," he says, "someone will call from *Time* magazine and all they can tell me is that the story is about income tax evasion, so I have to create an idea based solely on that. I then have to get the slant on the story and come up with a viable idea that best illustrates the topic."

But perhaps Bill Mayer puts it best when he explains how he uses his bizarre sense of humor as the ideal conduit for the creation of ideas. Mayer will often use sketchbooks to doodle ideas that have their initial origins in reality, but once Mayer puts his twist on them, they become hilariously unreal.

"What I do," says Mayer, "is remember and record ideas from life, but then process them through my imagination. The other day, I was sitting by the pool and this little kid is yelling 'I don't want a tomato! I don't want a tomato!' for 30

CHICKEN LITTLE'S BIG CONCERN Tom Barrett uses a classic anecdotal response when illustrating an article in *Monsanto* magazine about how the media has handled a variety of environmental subjects. Barrett illustrates close to twenty points—from styrofoam packaging to cow methane—that are raised in the article.

minutes. But when I'm sketching little ideas in my sketchbook, what comes out aren't drawings of little kids screaming. What comes out are bear traps with baby bottles on them, or a little dwarf that is holding a nail to his head and is about to knock it in with a hammer. Ideas like that seep into the subliminal. They're funny twists on what's really happening, but not literally what's happening."

ART THAT'S RICH IN INFO Robert de Michiell's humorous spot illustration speaks volumes (and it looks tasty, too).

SLICK PEN, SMOOTH COLOR Elwood Smith's expressive pen line is filled with watercolor wash. In the end, Smith speckles his art with "dandruff," small dots that he creates with Prismacolor pencil—a graphic treatment that a number of humorous illustrators have come to adopt.

HAVING A BALL Here is Jack Davis's infamous baseball stadium scene from *MAD* No. 2.

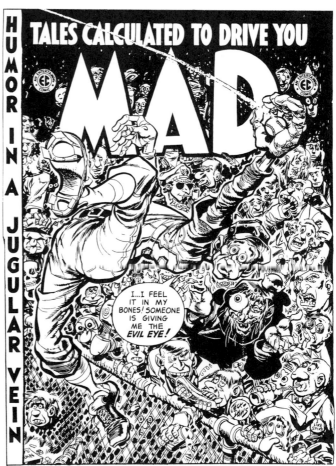

ELEVEN PLUS MA-DONNA Usually, Jack Davis will take an anecdotal approach when generating humorous illustration ideas. "I work pretty loosely," says Davis, "and if it's something I really enjoy drawing, it goes pretty fast. When it gets down to doing really tight work and the client is pretty picky, you can have it, because I don't want it."

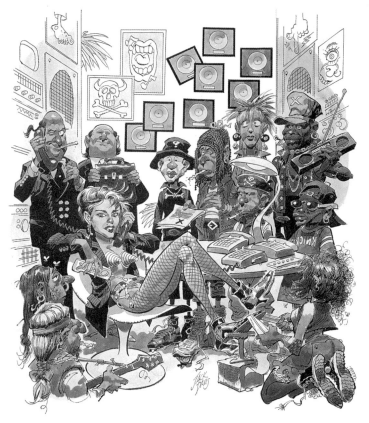

SANTA'S DUDS Mike Lester humorously illustrates *Santa's New Suit*, a delightful interactive children's book in which a fold-out Santa is redressed in ten different costumes—from a pirate to a ballerina.

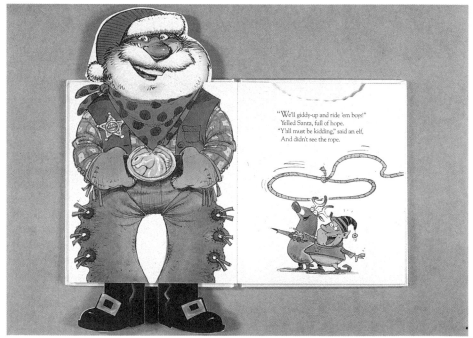

ROUGH CROWD

A LOOK THROUGH THE EYES OF THE HUMOROUS ILLUSTRATOR

Perhaps there's no better way to appreciate a humorous illustrator's creative thought process than by studying thumbnail sketches, rough drawings and preliminary layouts that set the stage for the finished illustration.

By looking at these skeletal drawings, one can better appreciate the ultimate, final illustration that was created. But perhaps most fascinating, are the conceptual changes that are made from one sketch to the next, or from comprehensive drawing to finished art. Arnold Roth adds a hot dog in his finished art, Robert de Michiell has his passengers transfer from the #9 to the #3 train, and Lou Brooks's fish evolves everything but feet.

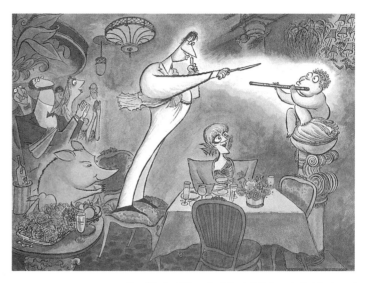

HUMORING THE EATERIES One of the best things about *Esquire* is their yearly Best Restaurant review, which is almost always illustrated by Arnold Roth, a contributing editor to the magazine. Roth is sometimes provided with photos for some of the restaurants, but for others he has to "totally wing it. But you can get a sense of the restaurant based on the description, or if it's very upscale, or whatever. You just think about the description and use your imagination, basing it on reality, or what you assume is reality." Here, Roth relies on a smattering of photographic references and his vivid imagination to draw the interior of Atlanta's Capriccio Ristorante.

REALISM WITH EXAGGERATION Jack Davis combines semi-realistic portraiture with elements of visual distortion to create this hybrid humorous illustration.

SKETCH

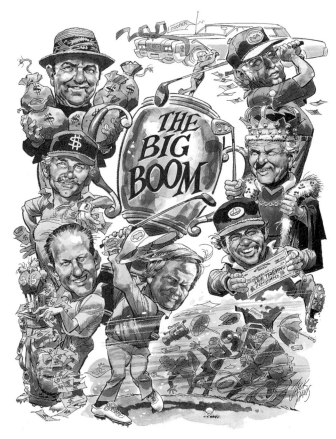

PUBLISHED ART

SKETCH

FINISHED ART

POP GOES THE ART Arlen Schumer and Sherri Wolfgang, the Dynamic Duo, create this book cover that some might dub "latter-day Lichtenstein" in its stylish approach. Note the major differences, but basic similarity between the rough and the final artwork.

FUN WITH ORGANS Patrick McDonnell approaches the decidedly somber subject of organ replacement from three visually hilarious perspectives. In the end, *Forbes* killed the cover story.

SKETCHES

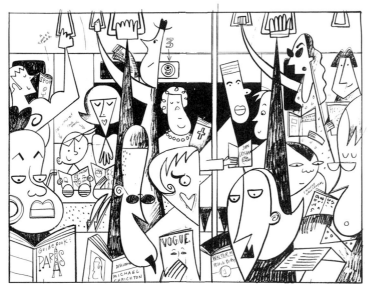

THE SUBWAY GOES THROUGH A HOLE IN THE GROUND If people on the subway looked this fun, I wouldn't need twenty-six bucks to take a cab to La Guardia. Indeed, Robert de Michiell's tube-riders look cool in graphite pencil, but they really come to life in vivid goauche. In fact, de Michiell has worked a self-caricature into the piece. He's the guy in the upper right reading, naturally, a book on Picasso. Ole!

SKETCH

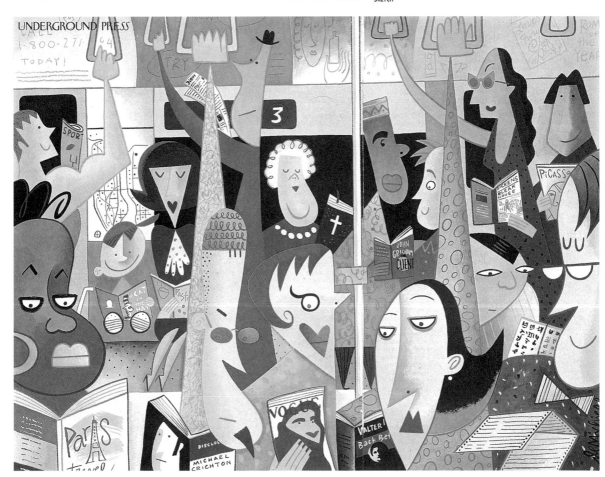

PUBLISHED ART

63

WHIRLING DERVISH Lou Brooks's meticulous manner of working is such that he must essentially work out all of his problems in a comprehensive pencil sketch before doing his final line drawing. The humorous illustration is an ad for MTV, the tagline stating "Just when you think you know what it is . . . It's MTV.

SKETCH

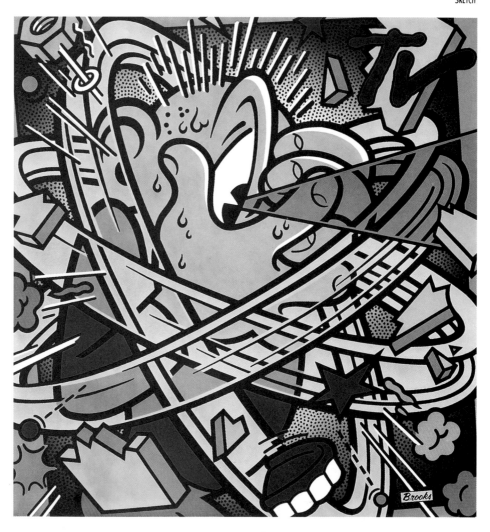

FINISHED ART

SKETCH

PUBLISHED ART

DON'T SKETCH DURING A SOLAR EQUINOX

Okay, I made that one up, but these doodles just inspired me. Indeed, Steven Guarnaccia's creative thought process is a fascinating thing to study whether you view these sketches in the order they were created, or in the haphazard manner in which we've presented them. They all feed off of one another and by exhaustively attempting to visually problem solve, Guarnaccia ultimately creates a delightful, anecdotal book cover illustration.

SKETCHES

PUBLISHED ART

THE EVOLUTION OF THE FISH To illustrate an advertising collateral piece for a corporate client, Lou Brooks first sketches a very loose fish character. He then flops the character in reverse and begins to inject some personality into his face and starts to flesh out some of the mannerisms. He then adds substantial detail, and by cocking the character's head to the left, poking a cigar between his teeth, sweeping in a motion line or two, and introducing nothing more than bubbles, suddenly the drawing comes to life. Once he thickens up the line, the fish looks like classic Lou Brooks, from gill to fin. Brooks then draws his line art and colors his final version.

STEP ONE

STEP TWO

STEP THREE

STEP FOUR

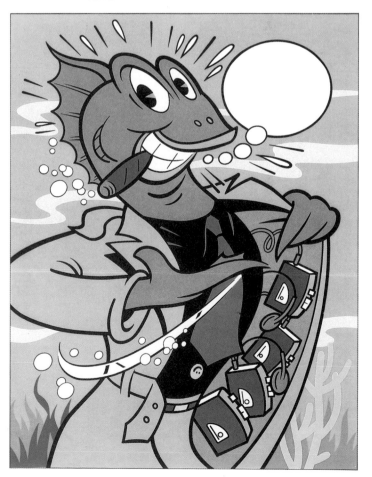

STEP FIVE

MAKING JUICE Roman Genn suffers through the sometimes excruciating sketching process, but it's all worth it in the end when he finally reveals a brilliant caricature of O.J. Simpson, a surprisingly difficult subject to caricature. Greatly derivative of David Levine's crosshatch caricature style, Genn emigrated to Los Angeles from the former Soviet Union and works as a freelance humorous illustrator specializing in caricature.

SKETCHES APPEAR HERE AND ON FACING PAGE.

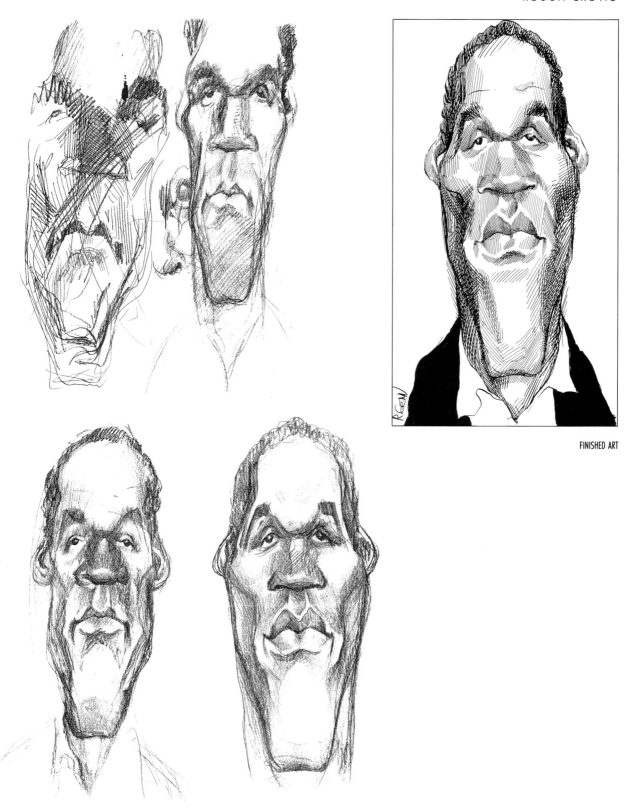

FINISHED ART

GRITTY CARICATURE

Since my word processor doesn't include a key that's able to pound out that weird-looking symbol that he now uses instead of his name, I'll have to refer to this caricature as one of Prince. The piece was created by Hanoch Piven, and even as he worked on his studies and sketches, Piven knew he would employ a piece of sandpaper to represent Prince's closely cropped beard and moustache.

FINISHED ART

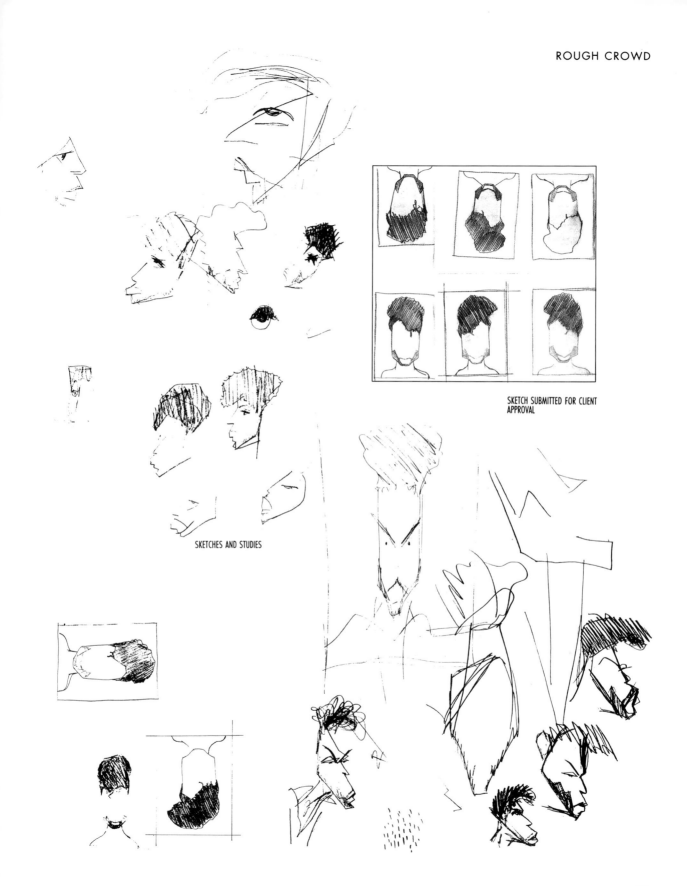

SKETCH SUBMITTED FOR CLIENT
APPROVAL

SKETCHES AND STUDIES

WHO NEEDS A BUNGEE CORD WHEN YOU'VE GOT A PHONE? Jack Davis creates eight rough sketches before one meets with approval from the agency art director who handled this ad campaign for Bell South Mobility.

SKETCHES APPEAR HERE AND ON FACING PAGE.

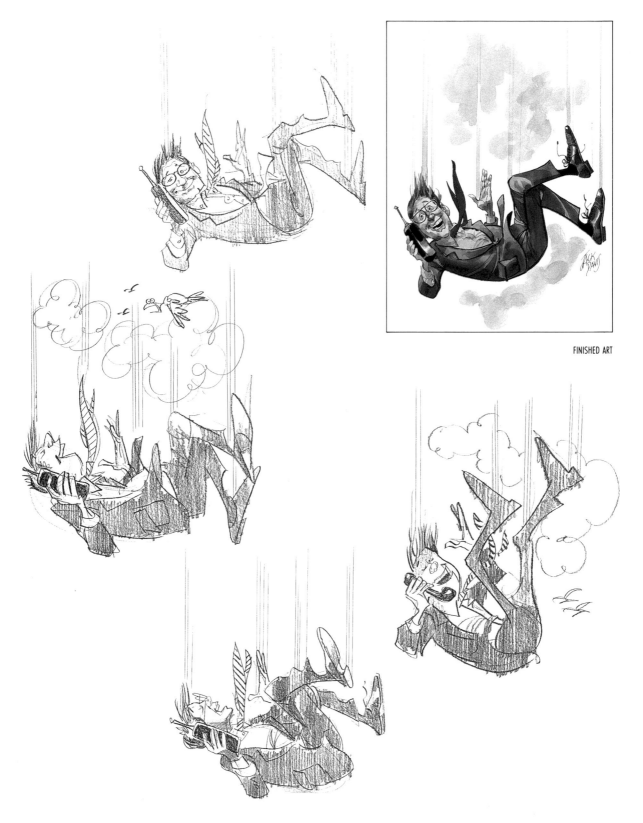

FINISHED ART

MOM, APPLE PIE, AND WORLD CUP SOCCER Because he prefers to create ideas in his head and then attack his paper with ink, Arnold Roth preliminary sketches are extremely rare. Nonetheless, when he creates work for *TIME* or the *New Yorker*, he's required to let the art directors see where he's going. In the end, Roth's final cover art incorporates an additional prop, a hot dog, to further promote the allusion to baseball bleachers.

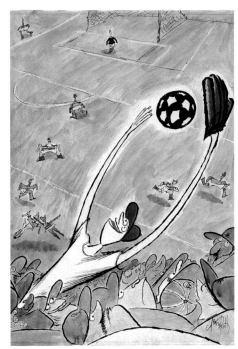

PRELIMINARY ART

LABORED ART When he works on an assignment, Elwood H. Smith will render a single, very thorough sketch with the ultimate objective of inking the sketch once it's been approved. However, Smith will lay the sketch down on his light box, place a crisp, new piece of paper over that, and pen his final art, as he finds this to be the best way to preserve the spontaneous quality of the sketch.

SKETCH

FINISHED ART

SIX OF SEVEN ORIGINAL IDEAS

KNOCKING ON APARTMENT 3-D'S DOOR To create the corporate logo for Apartment 3-D, a St. Louis based 3-D design firm, Mark Marek creates seven rough sketches in pen. Yet Apartment 3-D was so delighted with the sketches, that they selected the version showing a big-eyed character emerging from behind a door, opting to use Marek's pen sketch as the final art. The logo has been used by Apartment 3-D for seven years and has become a widely recognized image within the international 3-D community.

THE SEVENTH IDEA, WHICH THE CLIENT CHOSE

HAIRY WHITECAPS To illustrate the non-humorous subject of the United State's relationship with Haiti, Seymour Chwast creates a thumbnail of Uncle Sam, pushing his beard horizontally to the right. Chwast then elaborates the beard, making it appear as symbolic waves of whiskers on which he sets a sole Haitian forced to return to his homeland. Chwast follows the revised rough sketch closely, but makes the graphic decision to better render the waves themselves, in what is ultimately a witty illustration, almost akin to a clever political cartoon.

FIRST THUMBNAIL

SECOND THUMBNAIL

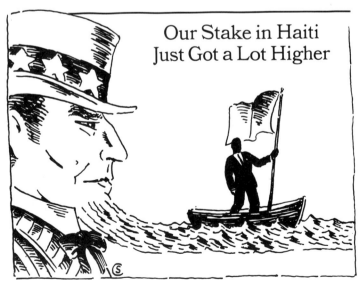

Our Stake in Haiti Just Got a Lot Higher

PUBLISHED ART

ROUGH DRAWING

HOW DO YOU FIT A MOON DOWN A CHIMNEY, ANYHOW? Personal pieces are always a blast to create, because there's zilch art direction. For my personal Christmas card for 1993, I wanted to do something colorful and simple, so as I sketched a rough drawing of Santa, I had a good idea in my mind of what the colors would be. But to make sure I liked the color choices, I quickly painted a darkened up copy of the rough before creating the final art. If the blue background on the final art looks a little lighter (but evenly colored), that's because it's a piece of colored paper on which I have spray-mounted my painted Santa character.

PAINTED VERSION

PAINTED GREETING CARD

QUICK AND DIRTY

PARTY When I create a rough sketch, the intent of the drawing is to convey a general feeling, yet not necessarily function as a perfect blueprint for the final humorous illustration. You can see in this sketch for one of my "Comic Caper Dial Cards," that I have made numerous changes in the final art, none of them particularly major. Elements have been deleted (the piñata gag in the lower left), characters have been redesigned (now a young blonde is being hoisted into the air), and other aspects have been reintegrated (a pair enter the house in the upper left).

SKETCH

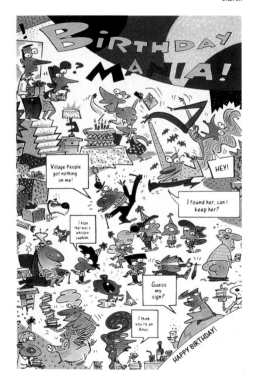

FINISHED ART

SKETCH

CROSS-SECTIONED FUN
In this ad for SEGA, I was told to "go crazy and have lots of fun," which is always music to my ears. Part ad, part game, kids were required to find certain high-tech activities within the scene, and once they did, certain key words in their answers offered some sort of secret message. In the final art, I created the solid lettering by cutting the characters from different color paper stocks and then spray-mounting them to the original art.

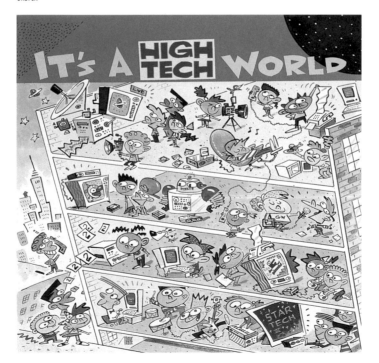

FINISHED ART

PICK AN IDEA Approached by the *St. Louis Post-Dispatch* to illustrate an article on the possible advent of commercial-free TV and how it may impact the advertising world, I was directed to draw up various commercial TV characters—from Alka Seltzer's Speedy to Mr. Clean—in an unemployment line. A couple problems with that idea: First, making visual reference to characters who haven't been seen on the tube in two decades wouldn't make a lot of sense (they weren't even alluded to in the article). Secondly, it would be tough enough to work this assignment into an already crammed schedule, so the last idea I wanted to illustrate was was one that would require the time-consuming process of drawing from reference photos or scrap. Instead, I proposed a different approach—actually eight of them—none terribly complicated, but all solid, fun ideas, any of which I would have the time to draw as final art.

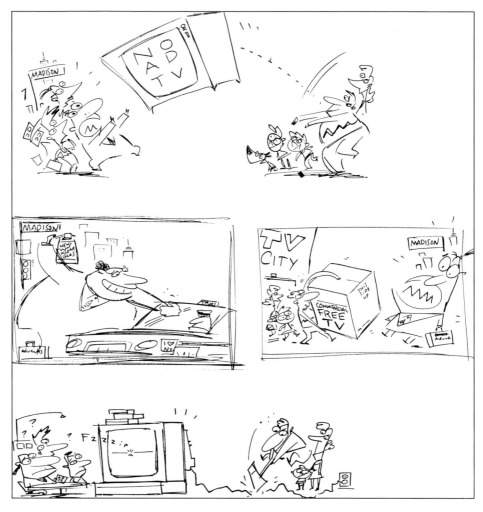

ORIGINAL IDEAS SUBMITTED TO THE CLIENT

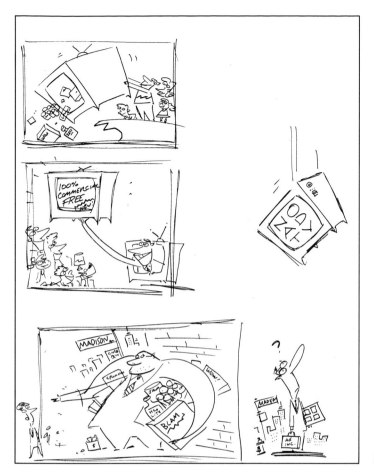

MORE ORIGINAL IDEAS

THE CLIENT'S CHOICE

SELF-POLICING While clients like the *Washington Post* tend to give me considerable creative freedom, I'm realistic about what I can and cannot get away with. To illustrate a Style Invitational contest in which readers were asked to come up with the "W.A.S.P. Curses" based loosely upon Yiddish Curses, I first created a Jewish character that I *knew* would be viewed as too ethnic—so I didn't even bother submitting that version. I redrew a more palpable character and faxed this version to Washington. I was then told to delete the lock of hair add a briefcase, and everything would be kosher.

VERSION ONE

VERSION TWO

FINAL VERSION

HUMOROUS ILLUSTRATION APPLIED

IT'S HERE! IT'S THERE! IT'S EVERYWHERE!

Certainly, it's difficult to recall a time when humorous illustration and cartoon-oriented artwork was utilized with more frequency than it is today, and the proliferation of humorous design in publishing, packaging, retail goods, television and advertising attests to the persuasive power of humorous imagery.

Yet, if humorous illustration is used in a broad variety of applications, each area is decidedly different than the next. For example, humorous illustration in advertising generally requires a different approach than editorial humorous illustration. When an illustrator produces a piece to be used on the packaging of a retail product, he creates this art differently than if it were to be used as an interior book illustration.

Illustration is by its very definition subservient to something else, and therefore must be created to accomplish certain goals—from getting a reader to investigate a manuscript to helping persuade a buyer to purchase a certain brand of snack cakes. If a humorous illustration *works*, it engenders something else, either tangible or intangible.

EDITORIAL VS. ADVERTISING: DIFFERENT WORLDS

If a visual component such as a typeface is appropriate or inappropriate for a particular application, the same is true for hu-

"TACTICS"

"GONE HOLLYWOOD"

CLOWNING AROUND
While it's rare for Elwood H. Smith to work in black and white, his humorous line art has spontaneous appearance that is quite appealing. "My favorite thing," says Smith, "is when I have one or two characters in a simple spot illustration. That's probably the happiest experience for me, because it's the simplest. If I could chose what I wanted to do, it would be these simple things."

morous illustration. Imagine for a moment the lighthearted typeface used in the "Gilligan's Island" credits and think of the Old English typeface generally used on the cover of a Bible. Okay, now reverse them. Old English typography would hardly promote the humorous attitude of "Gilligan's Island," and unless the Bible has suddenly come to include a book written by an apostle named Shecky, augmenting its cover with a silly typeface would hardly be fitting.

Humorous illustration works on a similar level, and just because a humorous illustrator's work appears in high-profile consumer magazines, doesn't mean that his work will automatically be used to help sell cheddar cheese that comes in a spray can.

Arnold Roth's work is a perfect example of this. Universally regarded as one of the nation's preeminent humorous illustrators, Roth's wildly surreal drawings have appeared on the cover of *Time*, and within the pages of every top magazine

in the country, yet rarely is he hired to illustrate an ad or create art for packaged goods.

After studying Roth's art, the reason should be obvious. While his anatomically-askew characters pique one's curiosity when encountering them at the introduction of a magazine article, it's difficult to image the same characters helping peddle an already conservative client's new line of fat-free TV dinners. From the client's perspective, it's tough enough market share, so why would he want to make the task any more difficult by employing a Kafka-esque cast of characters as pitchmen?

"I've done miniscule work in advertising," says Roth, "not that it ever broke my heart. On a monetary level it would have been great, because as you know, the bread is five times as much. I was never really keen on advertising anyway because the agency plans everything, and even if the humorous illustrator comes up with the idea, it's so circumscribed because the

TIME-ING IS EVERY-THING If Arnold Roth's work is appropriate enough to illustrate *Time*, then why isn't it used in advertising? Says Roth, "A former top agency art director, said it was because agencies didn't know how to 'comp' my art. Agencies like the way I draw and like my work, but when they would ape my style and draw up an idea to show a client, it wouldn't make any sense because I wouldn't have come up with that kind of an idea."

client doesn't want to antagonize anyone. By the end of the project, you've got fifty guys in a room telling you that you drew the wrong kind of shoelaces on a character."

SURVIVING BOTH WORLDS

However, a number of humorous illustrators have been able to successfully straddle the fence between editorial and advertising because their graphic styles and visual approaches are innocuous. Like Roth, Elwood H. Smith's characters are clearly wacky, yet there's a softness to their edge. Similarly, Mike Lester's illustrations are wildly funny, yet stop short of being offensive or venal, and it would be

difficult to imagine an application that *wouldn't* be appropriate for Lou Brooks's boldly graphic style.

But surviving the two worlds isn't without its headaches. While eighty percent of the work that comes out of Mike Lester's Rome, Georgia-based studio is used for advertising, he says that there's a higher "annoyance factor" when creating advertising, as opposed to editorial, illustration.

"After I've completed an advertising assignment," Lester says, "sometimes the art director will return the drawing to me saying the client thinks the art is a little bit too 'mean spirited.' I say it's a fat guy holding a donut—that's not mean spirited! I don't think there's anything improper about that. But when you're dealing with humorous illustration, you're

HE MOVES COAL, BUT NOT IN A BIG WAY The stylistic flexibility of Steve Bjorkman's graphics allows his work to be applied to advertising, editorial, greeting cards and products. "I don't draw that large," says Bjorkman, "because I tend to lose my spontaneity because my hand doesn't work that freely when I work big."

already skating on thin ice because there has to be some sort of visual lampooning taking place. If there isn't, then you're dealing in realism."

Yet because advertising rates are significantly higher than those paid on editorial projects, Lester is generally amenable to making changes to his drawings when they are applied to advertising. "I really don't mind making changes to ad work," says Lester, "because it pays better. But when it comes to editorial work, I'm resentful of making changes. It doesn't happen that often, but I do resent when a magazine art director tells me how I should draw a snowman with a darn turkey in his hands, especially when I'm only being paid six hundred dollars."

Like Lester, the majority of Elwood H. Smith's work is done in advertising, but when Smith does editorial work, it's usually with a very high profile in the nation's top consumer magazines. It's that high profile that tends to buffer Smith from advertising clients who are usually more than willing to ask a humorous illustrator to debug a character's eyeballs or help him loose fifty pounds with the swipe of an eraser.

"Advertising has always been a decision-by-committee proposition," says Smith, "and when there's a lot of money involved on a campaign, things go through so many people that it's bound to water down the effort. I have the advantage now because I have a much higher profile in the big magazines, so clients sort of expect me to draw characters with big, funny noses from the very onset."

Having never made much of a concerted effort to actively solicit advertising work, most advertising assignments have

found me. Therefore, for those art directors and clients that have gone to the trouble of tracking me down to my 250-square-foot studio in St. Louis, they already have a pretty solid idea of how I will, in all probability, handle their project. It's a nice position to be in, and while I've had my fair share of advertising headaches, they occur less and less.

Nonetheless, I've always thought of my style as being easily employed to a broad spectrum of applications. In fact,

WE'LL ASSUME THE HOME VERSION OF THE NEWLYWED GAME ISN'T AMONG THE FIFTEEN, RIGHT? When it comes to advertising work, Elwood H. Smith admits that setting prices is "sort of a game. I would also say that with almost every humorous illustrator I know, the compensation for lesser money is creative freedom. If the project looks really fun, I'll do it for a little less."

IT'S THE GAME OF LIFE, AND WE'RE ALL JUST PAWNS Because my humorous illustration approach straddles the fence, my work can be used for broad applications, from game boards for the Children's Television Workshop, to game boards for Coor's beer (go figure).

the primary reason I became a freelance humorous illustrator in the first place was the mercurial nature of the business. Day in and day out, when the phone rings in my studio, I never know what the assignment will be. Perhaps it's the back panel of a cereal box, a series of spot illustrations for a magazine, an element for an advertising campaign, or a fistful of greeting card assignments.

It's the mystery of it all that excites me, so I suppose I have made a subconscious effort to insure that my visual sensibilities and conceptual approach is effectual in virtually any communicative area.

However, this is not to say that I approach advertising, editorial, packaging and greeting card projects from the same creative perspective. In the interest of better clarifying the major areas of application for humorous illustration, a general review of each area follows:

CONSUMER MAGAZINE EDITORIAL

Perhaps the predominant forum for humorous illustration, mass-market consumer magazines like *Time*, *Esquire* and *Rolling Stone* employ humorous illustration to emblazon their covers, augment feature articles, and even dress up news briefs that

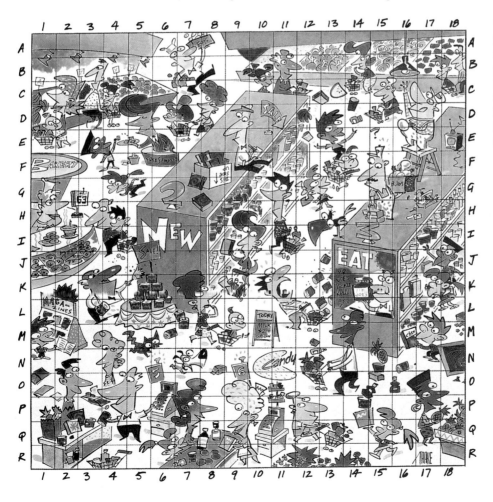

TRIPLE CROWN Why is this supermarket scene broken up into 324 squares? It's a game I invented called "Kid Grids." Alongside this art were five squares; kids (adults too) would have to guess their placements (K-10, F-16, etc).

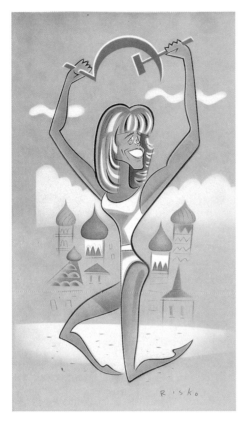

would otherwise be lost in a sea of copy and advertisements.

Since the major consumer magazines pay top rates for illustration, they are able to attract the preeminent illustrators in the business, and there's an ancillary benefit to the artist. Because these magazines have circulations in the millions, the exposure for the illustrator can be staggering, often resulting in assignments from other advertising, editorial and corporate clients.

"When you do a *New Yorker* cover," says Arnold Roth, "suddenly you get calls from people you've never heard of. You could have done covers for a million other magazines, but nobody calls you. But art directors *do* see the *New Yorker* and the *New York Times*. Generally, they're as lazy

as artists are, so that's why you see them using the same illustrators over and over. You know, ten million people bring in their portfolio every week, but they'll see one job done by somebody on the cover of the *New Yorker*, or one or two other key publications, and they'll give them the assignment."

And while Drew Friedman's humorous illustrations have started appearing in top mass-market magazines like *Time, Entertainment Weekly*, and *GQ*, the sometime underground comic artist refuses to work with certain magazines. "I wouldn't work with *National Review* if they were to call," says Friedman. "Actually, I got a call from *Hustler* the other day, and the art director was very nice. He said if I didn't want to do the job, I didn't have to call him back. I would have been tempted to call him back, but I was pretty busy at the time. I'm not interested in doing work for *Hustler*, but if I was starving or didn't have anything else going on, I might take the job."

But if you think humorous illustrators who create work for the top consumer magazines are allowed lengthy deadlines of a week or two in which to complete their assignments, guess again. Since many of the biggest mass-market magazines are published weekly, they have no option than to work with illustrators who can deliver art on short notice.

"Believe it or not," says Robert de Michiell, "you'd be amazed at how many overnight assignments I receive. Generally, I like to have a deadline of a week, or sometimes ten days, but oftentimes I find people needing things at the last minute. In fact, *Entertainment Weekly* often will call me on a Friday and need art in their

hands by Monday."

And while one would assume that budgets would take into account a ridiculously short deadline or a requirement that the humorous illustrator work over a weekend, they usually do not. Friedman, however, recalls being paid an extra $500 by *Time* magazine for personally driving his illustration to their Manhattan offices—through one of the worst blizzards to hit the East Coast.

"Sometimes," de Michiell points out, "an art director will say 'we can give you fifty to one hundred dollars more,' but that's about it because they pretty much have their illustration budgets set. And with these short deadlines, they may have just decided to include a humorous illustration at the last minute, so they never really even had a budget for art to begin with."

Yet as long as there are magazines, says de Michiell, there will be room for humor-

SPIKE AND BARBRA AT SUNRISE "In a busy week," says Robert de Michiell, "I'm doing an illustration a day—including weekends. I'm pretty disciplined, though. I have a set routine and I know how long the sketches take me, and I know how long it'll take to finish."

MAKING THE GRADE "I keep celebrity photos on file," says Drew Friedman, "and if I need to draw a particular pose, I'll use my wife as a model. In fact, *I* posed for that gesture of Chevy Chase acting like a jerk in the background."

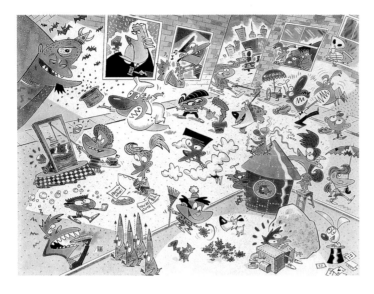

KIDS GOTTA HAVE MAGAZINES, TOO! I love creating work for children's magazines. It's important to reflect kids of different ethnic backgrounds in pieces like this, so I always add minorities so an art director doesn't prod me to do so.

ous illustration. "No matter how grim the magazine is," de Michiell continues, "there are always going to be a few stories that will be amusing. If you have a fictitious article about Mario Cuomo hitting Ed Koch with an ax, you can't use a photograph for the story, you'll need to hire a humorous illustrator to draw it."

TRADE MAGAZINE EDITORIAL

The financial boom of the 1980s may have helped to spawn supply-side economic theories, but the influx of money also engendered a new breed of specialty magazines intended to address the idiosyncratic needs of parochial groups with plenty of discretionary cash to spend on advertised goods and services.

Suddenly, magazines with names like *Lugnut Enthusiast*, *Poodle Groomer* and even *Spastic Colon Monthly* appeared not on retail newsstands, but in subscriber mailboxes.

To a considerable degree, these "trade" magazines affected consumer magazines because their specialized editorial content was desirous to advertisers. Their circulations may be smaller, yet trade publications are targeted to an idealized readership and their advertising rates are tantalizingly low, especially for those clients who may have limited ad dollars to spend.

Today, trade publications flourish, with *many* arguably becoming pseudo-mainstream, consumer titles. By strict definition, *Skiing*, *MacWorld*, and *Runner's World* are trade publications because their editorial content is of narrow focus, but one could certainly view these magazines as consumer publications.

Generally speaking, trade magazine illustration budgets are twenty-five to fifty percent lower than those paid by consumer magazines, yet more and more illustrators find them to be wonderful, harmonious forums for their work.

To survive the recession of the 1990s that had a particular impact on advertising, Elwood H. Smith has found himself accepting trade magazine assignments. "Today," says Smith, "you need to do more work to make the same money. For a lot of college and religious magazines, they may only pay $300 to $500 for a full-page color humorous illustration, and since I usually like to get $250 to $300 for a spot illustration, the only way I've been able to work with low trade magazine budgets is essentially to draw a spot that they then blow up to a full page. You need to do creative things like that to survive in this business."

Because I tend to work very fast and rarely linger on a single project for longer than a day or two, I happily work for trade

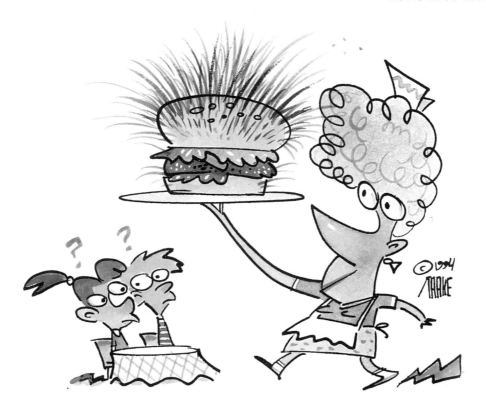

LOVE THOSE HAIRY HAMBURGERS Why would a waitress be bringing a couple kids a hamburger with a wig growing out of it? I wish /could remember. However, I do recall that this was one of five or six spot pieces I did for *Family Fun* magazine.

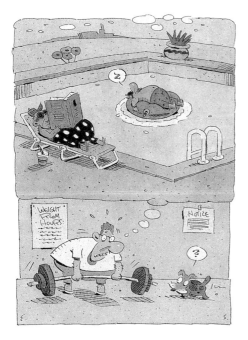

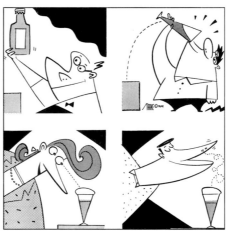

BY THE FIFTH BREWSKI, YOUR TASTE BUDS ARE IN A COMA Here I illustrate the four things a discriminating beer connoisseur is supposed to do—study the bottled clarity, eye the head, appreciate the aroma, taste the brew—for Zymurgy, a trade magazine for the home brewing industry.

WHO WANTS TO PUMP IRON WHEN YOU COULD BE OUTSIDE TANNING YOUR CONSIDERABLE GUT? To survive and prosper in the budget-tight 1990s, Elwood H. Smith finds trade magazines to be solid markets. This page was created for *Endless Vacation*, a special-interest magazine for retired people.

magazines. Even though their rates are certainly lower than consumer publications, the disparity is slowly becoming less and less. But more importantly, art directors at trade publications tend to be sincerely appreciative of an artist's agreement to work at a reduced rate, so they compensate for this by extending a healthy level of creative freedom to the humorous illustrator. And often, that can be more rewarding than money.

ADVERTISING

Without question, the field of advertising is where the money is, so it's no wonder that many humorous illustrators concentrate on this market.

Slammed between the eyes by pocketbook-tightening clients, the advertising world was also required to dramatically cut its staffs, provide more services in-house, and instill competitive bidding procedures, a practice usually used when one solicits companies to seal one's driveway. Even with this budget-cutting, advertis-

ing fees for illustration remain ridiculously high, and humorous illustrators are still paid thousands of dollars to create a single humorous image.

And if advertising budgets are legendary, so are the headaches. In fact, humorous illustrators are best advised to allocate ten to twenty percent of the fee for a couple crates of untainted Tylenol. Almost invariably, advertising projects are committee-oriented, so the meddling can be substantial, and clients will routinely request that noses be made to look less phallic or facial expressions appear less demonic, so it should come as no surprise that some humorous illustrators find it difficult working under such creative restrictions.

Although he has had little experience in advertising, David Cowles' head spins over the budgets that are thrown around on Madison Avenue. "Advertising pays like crazy," says Cowles. "It's goofy, the whole advertising thing, and what they pay. If you would have asked me a couple months ago if I wanted to do more advertising work, I would have said no because I had some pretty bad experiences, but things have been getting better. I've had projects that were killed at the sketch stage once the client saw where my final art would be going, and when it didn't get killed, there would be so many changes that I would just take the money and run, and I hated that. I'm not averse to advertising, but I still prefer editorial work because the content is more fun and I have greater creative freedom."

There are also ethical questions that continually arise when a humorous illustrator is approached to create art for a morally questionable client. Some humorous

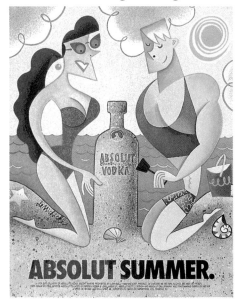

ABSOLUT DE MICHIELL
"For advertising work, my price would start at $2500," says Robert de Michiell. When he takes into account all the editorial humorous illustration he does in the course of a year—from magazine spreads to spot illustrations—de Michiell figures that his median price per illustration is $500.

illustrators will happily illustrate an ad for Budweiser, but would turn away Absolut Vodka. Some agree to illustrate print collateral for Winchester rifles, but not for Phillip-Morris. But Lou Brooks says if a humorous illustrator has those sorts of reservations, he should pack his bag.

"If you have those sorts of problems," says Brooks, "you're in the wrong business." Yet Steve Bjorkman, a self-described evangelical Christian, sees it much differently. "I disagree entirely with that," says Bjorkman, "because we all need to draw our lines somewhere. When I first started out, some client wanted me to do an advertising illustration for crotchless panties, but he assured me it would be in 'good taste,' and I was asked to participate in one of those Absolut campaigns, and I would have loved to do it. I'm not beyond economic temptation, and there are a lot of things I would do if I could rationalize them. I hate to turn that stuff down, because I could use the money, but I couldn't look at myself in the mirror. I'm trying to live my life by principles rather than by the pocketbook."

For Jack Davis, moral and ethical questions are often answered by a growling stomach. "It always depends on how hungry you are," Davis explains. "I did have a chance to get the Joe Camel campaign, and I'm kind of glad that I didn't get that. That campaign has become pretty controversial, and I just don't want to get involved in any controversy because I don't want to hurt anybody or make people mad."

"I don't smoke," says Bill Mayer, "but I feel that everyone has a right to do whatever they want, and in the past I have done work for cigarette companies like R.J. Reynolds. I think we can justify whatever we want to justify."

PRODUCT/ PACKAGING

Like advertising, creating humorous illustration for products and packaging also pays inordinately well. And while a humorous illustrator can be assigned this work through a corporation, ad agency or design studio, the general objective is that

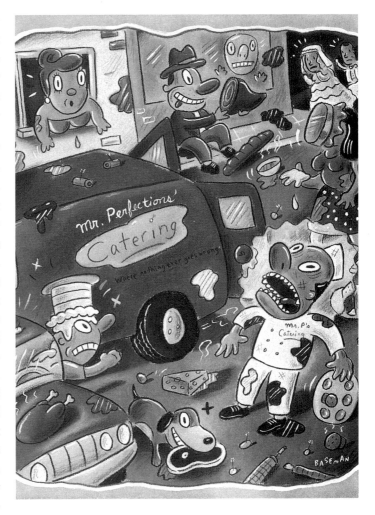

CATERED ROLES Seeing his role as multi-faceted, Gary Baseman accepts that the primary purpose of his humorous illustration work is to get people to read the articles that they augment.

THEY'VE BEEN FRAMED!
Humorous illustration is being used on a variety of products, including this laser-etched frame created by Steve and Carl Bjorkman for Amerigo. From a distance, these white on black squiggles work as decorative design, but upon closer scrutiny, one sees that the squiggles are actually impressionistic sketches of people.

PRODUCT PACKAGING FOR PEN-LOVING PUBESCENTS Bill Mayer may draw pretty cool monsters, but he's also quite able to create homo sapiens, four of which he's emblazoned on packaging for a Scripto pen line for back-to-schoolers.

the art be bold, or at least somewhat compelling, in its visual nature.

Few humorous illustration styles are better suited to product packaging than Lou Brooks's hard-edge graphic approach, so it comes as no surprise that a client like Parker Brothers would call on Brooks to redesign the fiftieth anniversary edition of *Monopoly*, a plum project if there ever was one.

Today, most of Brooks's work is created on the computer, but for years he employed a production technique that enabled him to reproduce his super-dense line work as a solid black, and not broken down as part of the color separation. It's

this technique that greatly enhanced the printed appearance of Brooks's work not only on packaging, but every time his art came in contact with a Heidleberg press.

"For years," says Brooks, "I tried to figure out how in the hell to separate my black line art from the rest of the colors because I didn't want dots in the line work, I didn't want it to look like a halftone. So what I would do, is create the line art in black on a clear piece of film, and then create the colors as a separate, overlaid element. That overlay could then be scanned in four-color process, and the black could then be shot as solid line work."

Brooks's broad knowledge of production is rare for art directors, let alone humorous illustrators, and he learned most of his technical tricks while working as a teenager for the now defunct *Philadelphia Bulletin*. "It was invaluable training for me," says Brooks, "although I didn't realize it at the time. The old-timers would also play tricks on me. Some of the production guys would give me a bucket and tell me to go to the typesetting department to get them a bucket of benday dots. So here I am at 4:00 A.M. walking around the *Bulletin* going from one department to the next asking everyone where the benday dots were."

Brooks, Steven Guarnaccia, Gary Baseman, Drew Friedman and Elwood H. Smith were all part of a unique packaging product that employed their humorous illustrations on Pentech pencils, Bill Mayer recently created wild packaging for a line of Scripto pens, and Steve Bjorkman has developed some unique humorous designs that have been laser-etched onto picture frames—all indicators of how humor-

ous illustration is being used in unique ways on products and packaging.

A considerable amount of my packaging work has been on cereal boxes, and I suppose I've produced over a dozen "back panels," primarily for Ralston Purina lines. When creating an illustration for a cereal box, I recall how as a kid I could read a cereal box for hours as I feasted on one brand or another of sugar-coated oat whatevers, so when I sit down at the drawing table, I want to make sure that my image contains an overkill of imagery—that way when you come back to the drawing, bowl after bowl, you'll discover something new in the art.

And since I also create and draw a substantial number of games and activities for children's publications such as *Sports Illustrated For Kids*, *Kid City*, *Nickelodeon* and *Weekly Reader*, I've been given what I feel is an inordinate amount of freedom to design "game-oriented" cereal box art that is sometimes on the edge. On a maze for Urkle-Os cereal, I never would have imagined that my weird reference to an old woman pleading to be *carried* across the street would be approved, and I certainly didn't expect that a marginally tasteless reference to lemonade would make the cut, but it did.

While I always have an absolute blast creating packaging art of this type, the real credit has to go to those consummately professional Ralston Purina art directors who have consistently given me a long creative leash to do what I do best.

GREETING CARDS

To find a greeting card line that doesn't employ humorous illustration is like find-

SHARP PENCILS Lou Brooks, Gary Baseman, Steven Guarnaccia, Elwood Smith and Drew Friedman created these ultra-hip, designer pencils for Pentech in 1992. While their styles are quite varied, their graphics are all firmly grounded in humor.

SOMEONE DIDN'T LOOK TOO CLOSELY I continue to be amazed at the amount of creative latitude I'm given on advertising and packaging projects, particularly when all other humorous illustrators I know complain that they're constantly restrained creatively.

ing a beach that doesn't have sand.

Indeed, greeting cards continue to be rife with laugh-inducing graphics, a far cry from the fluffy animal art which was synonymous with the greeting cards of a scant decade or two ago.

Not a market usually associated with

huge budgets ($500 is *top* pay for card cover art), humorous illustrators who create greeting card art are generally afforded a significant level of creative freedom which almost always takes the sting out of any non-spectacular fee.

While every greeting card company has their own unique way of working with humorous illustrators, almost all of them assign specific projects to humorous illustrators, or encourage them to submit (usually on spec) card ideas incorporating their copy *and* art.

Steve Bjorkman has been particularly successful at parlaying an impressive humorous illustration career into a mini cottage industry as a greeting card artist. With the aid of his brother, Carl, the Bjorkman brothers have formed a partnership with Recycled Paper Greetings to create greeting cards that pay royalties to the brothers (a five percent royalty is regarded as an industry standard), and currently greeting card payments amount to approximately half of artist Bjorkman's income.

"Carl handles the business end of it," says Bjorkman, "and I handle the art. Frankly, I wouldn't be involved in any of this if Carl wasn't here because I'm not much of a self-starter. We've pretty much made the decision that we won't get involved with greeting card projects that don't pay a royalty. Basically, we create the card and take the risk. If it sells, we make some money, and if it doesn't, we don't."

Yet as anyone involved in royalty projects can tell you, it can take what sometimes seems like an eternity before those first royalty payments come in. "It's such a slow build," says Bjorkman, "that if I died tomorrow, we would still be earning royalties for a year before you started to see the payments drop. Some humorous illustrators would rather do the job and get the paycheck, but some people like the roll of the dice, and that's why I'm willing to take the chance."

Having created greeting card work for Hallmark, American Greetings, Gibson, Paramount and others on both a fee and a royalty basis, I see merit in either arrangement. That's why, whenever possible, I like working out a deal in which I am paid to create the art for a card, and am also paid a royalty that is negotiable. I also like to roll the dice—after I've had a chance to fix them.

TELEVISION, ANIMATION AND CD-ROM

When it comes to animation, patience is not only a virtue, it's a necessity.

Next time you watch an animated com-

mercial on television, think about this: Every one second of filmed animation requires approximately 12 drawings. That's 360 drawings for a thirty-second spot, 720 for a one-minute segment and, as long as we have the calculator out, 64,800 doodles for a standard hour-and-a-half feature.

Not that all those drawings are crunched out here in the United States, they're not. Increasingly, ink on cel duties are fulfilled in Asian sweat shops where underpaid hunchbacks sit chained to light tables rendering cartoon characters over, and over, and over.

Thanks to revolutionary animated programs like the "Simpsons," the "Ren and Stimpy Show," "Beavis and Butt-head," MTV's "Liquid Television" and showcases like the *Festival of Animation* and the *Tournee Of Animation*, the art of animation is going through a rebirth of sorts.

Increasingly, animated characters are being conjured up by noted humorous illustrators who determine how big their characters' noses will look, how beady their eyes will appear, and if their hands will include three, instead of four, digits.

After designing a number of television commercials, most notably the series of Acura ads using a dog character named Leonard, Everett Peck was able to develop his *Duckman* comic book into a show for the USA Network. Peck describes *Duckman* as an animated show for adults, yet when he makes occasional forays to comic book conventions, he is genuinely surprised at the number of kids who are fans of the show. "All these little super hero fans ask me what powers *Duckman* has," laughs Peck, "and all I can tell them is 'Well, he's p----- off.' "

"Since *Duckman* started out as my own comic book," Peck points out, "the animated show is also pretty true to my vi-

DON'T TELL HIM THAT THERE ARE DONUTS ON THE EMPIRE STATE BUILDING'S OBSERVATION DECK King Kop, a three-dimensional character first created by Mark Marek for a *They Might Be Giants* video, is once again created, but this time on the computer. Marek was commissioned by Nickelodeon to fully develop King Kop for their new animation showcase for kids entitled "Blam!"

DRAW, O COWARD This is an example of a palindrome, that is, the first half of the sentence can be reversed to form the last half of the sentence. Steven Guarnaccia has illustrated two collections of palindromes; these examples are from *Madam, I'm Adam* by William Irvine.

sion. I'm pretty much involved in every aspect of the show, and I do a lot of the design and drawing required."

Yet Peck's experience of having an entire *show* centered around his characters is rare. Instead, when humorous illustrators are employed to create characters or design the look of an animated spot, the producers are usually coming to them for their unique visual style.

Known for his humorous illustrations that borrowed heavily from animation of the 1950s and 1960s, David Sheldon was a logical candidate to design "fake commercials" (most notably 'Log') for the "Ren and Stimpy Show." "My stuff," says Sheldon, "looks a little like early Hanna-Barbera. I grew up watching things like "Huckleberry Hound," "Topcat," "Quick Draw McGraw," and "Yogi Bear." I was also influenced by Disney animation of the 1950s which had a hipper kind of look, particularly *Alice in Wonderland*" which was designed by Mary Blair. "Rocky and Bullwinkle," "Mr. Magoo" and "Gerald McBoingboing" were other cartoons that I was a big fan of." It should therefore come as no surprise that when one sees Sheldon's "Ren and Stimpy" work, they feel as if they've traveled back in time to the Kennedy era.

I, too, have designed a fake commercial for the "Ren and Stimpy Show," one that advertises a nasty-sounding product called 'Dog Water,' and I was delighted with the end result. At the beginning, I was provided with little more than a loose stick figure storyboard and a rough cut of the audio. After listening to the dialogue for a few times, I began to see the characters in my head, and then it became a simple process of tightening up my design of

them.

Once I felt comfortable with my design of the four main characters, I presented the sketches to "Ren and Stimpy" producer Bob Camp. We agreed on a few minor changes (I think we added ten years to the father character, among other things), and then I proceeded to design every detail of the three-minute animated segment—from the pout of the female lead's lips, to the color of a tablecloth.

Another technology that has piqued the interest of the humorous illustrator is the introduction of CD-ROM. Essentially the size of an audio CD, a CD-ROM disk is inserted into a computer's drive unit and allows an individual to use the keyboard and mouse to interact with the CD program.

"I think we're in a transitional period," says Everett Peck, "and as there are fewer magazine outlets for humorous illustration, there will probably be an increase in electronic outlets as we get more into online computer services and CD-ROMs.

Knowing frightfully little about computers, I was a little reticent when a computer software company approached me to design a segment of a CD-ROM for Time Warner. Surprisingly, I wasn't required to draw my art with any type of pen attached to nuclear electrodes or anything, and I was delighted to learn that there would be no need to paint my colors using a dizzying mélange of keyboard commands. Instead, I simply drew the art, they scanned it, and then did whatever they had to do to make elements of the game disappear at the click of a mouse.

But I particularly enjoyed creating a number of simplified, cycled animation effects that intermittently appear on the

computer screen. The project was such an unexpected delight, that I'm certainly interested in seeing what opportunities are in the future for humorous illustration and CD-ROM.

BOOK PUBLISHING

Long a forum for humorous illustration, books (the really good ones) often have their otherwise gray pages broken up with a healthy smattering of funny graphics. Just look at *this* book. Would you even *care* about it if it didn't have all these cool humorous illustrations? Of course you wouldn't.

Happily, book editors, writers and art directors at the top publishing houses know the value of a strategically placed humorous illustration on the cover of a book, inside, or both, so through the course of their professional lives, few humorous illustrators sneak by without illustrating at least a handful of titles—some they'd like to remember, others they'd like to forget. In fact, of all the humorous illustrators interviewed for this book, only two have yet to illustrate their first book.

To be sure, book illustration is almost always a delightful experience, and one that can only be bettered by a higher royalty and sixty-three straight weeks on the *New York Times* best seller list.

Yet book illustration doesn't generally pay what it used to, a sign endemic of these budget-tightening times. The illustrator of well over a dozen books, Arnold Roth was recently approached by a major publisher to illustrate a pithy manuscript. To get a better idea of the fee he should negotiate for, Roth contacted an old Manhattan literary friend. After explaining the

project's specifications, Roth suggested to his friend that he would like $40,000 to do the project. Aghast, Roth's friend retorted "Arnie, I don't think you understand. In book publishing, there's $4,000 and there's $4 million, but there's no such thing as $40,000."

Having illustrated and/or authored over ten books, I can tell you this much; they're a heck of a lot easier to illustrate than they are to write. But what's most appealing about illustrating a book, is the almost uncommon amount of creative freedom that is afforded to the illustrator, or at least that has been my experience, and generally speaking, the process of complementing a book manuscript with art is primarily a solitary experience ideally suited for hermits, agoraphobics, or humorous illustrators.

It would also be worthy to note that as

PUBLISH OR PERISH
When it comes to publishing, Arnold Roth has found that the budgets aren't spectacular—unless your name is Stephen King. "I try to avoid doing sketches," says Roth, "or even tell the art director what I'm going to draw. It just hampers the spirit."

many thirty- and forty-something humorous illustrators slowly come to terms with the capricious nature of freelancing, the notion of creating their own royalty-driven books sounds appealing—and more than possible.

Having had a taste of book work, Mike Lester is ready for more. "I've done a lot of book covers lately," says Lester, "and I really like it. Hell, I'm thirty-nine and I would really like to expand in some way rather than sitting around waiting for the

phone to ring. I would rather be more pro-active in what I do for the rest of my life. I do want to do my *own* work."

"I want to do children's books because I think the time is right," says Peter de Sève. "There are more kids than ever out there and parents are very anxious to find unique and entertaining things for their children. Today's parent is also hipper than their parents were, so they're more willing to try out strange things for their kids."

Bill Mayer also entertains the idea of doing children's books, but one thing always dissuades him. "There are a lot of things I'd like to get involved with," says Mayer. "I'd like to do children's books, but there's just not a lot of money in it. When I get involved in a children's book project, I want to prove to myself that I'm doing it because of my love of the art, not the money. But then I get in the middle of it and say what the hell—it's much more fun making money. So I slap myself in the face and go back to the advertising stuff."

❖ DIGGING YOUR OWN GRAVE ❖

30. ❖ Go on a water-tasting trip through India.

❖ B. L. ANDREWS ❖

180. ❖ Use a public defender at your trial.

GALLERY OF HUMOR

HERE'S LOOKIN' AT YOU, KID Alex Murawski dots-until-he-drops to create a stippled, hyper-realistic cyclops.

YOU'D RUN AWAY FROM TALKING ROSES TOO! Peter Spacek's simple, attention-getting style works well to illustrate this ad for Ortho Rose and Flower care. Spacek's presentation may include cartoon-oriented elements like word balloons, yet the art must be considered a humorous illustration because its primary purpose is to serve a greater purpose, in this case, the selling of a product.

EXILE FROM EDEN Having partaken of the apple, God sends Adam and Eve on their merry way. Luckily for them, on the sixth day, God apparently made the motorcyle (and it was good). While it would be difficult to label Seymour Chwast a humorous illustrator in the traditional sense, his work often possesses certain levels of humor, even though he approaches his graphics from the perspective of a designer.

SAFE HOUSE Phil Marden's humorous illustration style is somewhat evocative of a sort of retro-50s look that is delightfully contemporary.

A CHIP OFF THE LINO-LEUM BLOCK To create his uncommon humorous illustrations, Randall Enos first cuts a master illustration on a linoleum block which he then inks in different colors and prints onto different colored paper stocks. He then cuts out different elements (a blue inked monster head on light blue paper, red inked eyes onto yellow paper, etc.) and puts them together in a collage-like fashion. In the end, Enos's work has a delightfully primitive appeal that is almost decorative in its aesthetic.

SCHOOL'S OUT Creating a substantial amount of work in the children's market—from magazines to greeting cards, products to packaging—I've always had fun drawing kids. In this two part piece for the *Chicago Tribune*, the countdown sequence actually ran on the cover of their Sunday Kid's Section, and then when you open the section, the doors of the schoolhouse explode and the kids screech out for their summer vacation. Believe it or not, as innocuous and safe as these kids appear, I will still hear an occasional comment from a client urging me not to make the kids look "too weird."

LOTS O' CRITTERS I think my son, Ryan, counted the animals and figured out that there were something like 333 of them in this piece which appeared on the back panel of *Hostess Hoppers* snack cakes. The idea here is that you have to find the ultra-cute little "Hostess Hopper" character (it's easy—he's the character that looks like he was drawn by someone else) within this menagerie. I've found that most humorous illustrators tend to shy away from complicated scenes like this but I absolutely love doing complex stuff like this. Happily, I have a good memory, so I was able to "fake" most of the animals.

PARROT-LESS PIRATES? THAT'S NOT RIGHT!

Peter de Sève's lush illustration style is reminiscent of classic children's book art, so it should stand to reason that pirates (9½ of them, to be exact) would be ideal subject matter for him. De Sève is vocal about young illustrators who slavishly steal their styles from successful contemporaries. "Style stealing shouldn't be done because it's disgusting and people should feel bad about it. But purely on a practical level, you'll never be successful as a humorous illustrator unless you bring something new to the table.

MAT THAT SPLAT! By dividing his illustration into two parts, Keith Bendis suggests the passing of time by creating dual panels that work symbiotically. The art humorously illustrated an article in *Reader's Digest* artistic terms.

TWO ARENAS Slug Signorino hilariously depicts the differences between the more positive world of advertising, and the comparatively negative world of editorial.

SMILE AND SAY "ILLEGAL PROCEDURE" Jeff Shelly's funny illustration showing a quarterback mugging for a press photographer is loaded with carefully planned action.

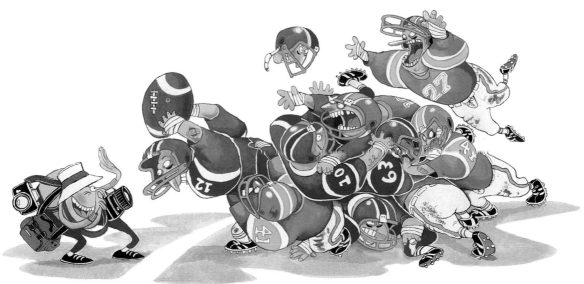

WHAT HAS FOUR WHEELS AND FLIES? This guy's car, of course. No seriously, that's the title of the article that this humorously bizarre piece by Rick Sealock illustrates. According to Sealock, the story discussed a man going through disorder in his life and therefore being unable to keep his car clean.

BON VOYAGE Rob Westerberg lets his airbrush spurt, spatter and spit to create this dynamic, succinct and fun piece. By slightly modifying the shape of the computer, Westerberg visually molds it to resemble a ship that's being christened with a bottle of bubbly.

IS THAT A PROBOSCIS ON YOUR FACE, OR ARE YOU JUST GLAD TO SEE ME? When Baseman became a professional illustrator in 1984, humorous illustration wasn't in vogue, yet today Baseman is one of the avant-garde leaders of the art form. Nonetheless, some clients will still voice objection to the big noses that Baseman routinely draws on his characters. "When an art director tells me that the noses are too big or too phallic," says Baseman, "I tell them that it'll get more women to read their magazine, or I put them on the spot by asking if their relationship at home is going OK. If I make them feel uncomfortable enough about it, they tend to back off."

THE DOGS OF WAR
Cameron Eagle's bulldogs fly *and* shoot bullets, thus making them slightly more dangerous than a pit bull in heat. Boldly rendered and certainly eye-catching, what's interesting is how Eagle varies the density of his line work by thickening it, and then thinning it out. The piece was created by Eagle as a self-promotion for the 1992 edition of *American Showcase*.

TIME FLIES WHEN YOU'RE IN HELL David Goldin combines pen, ink, watercolor and found objects like watch faces, cigar labels and stamps to create his mesmerizing collage humorous illustration.

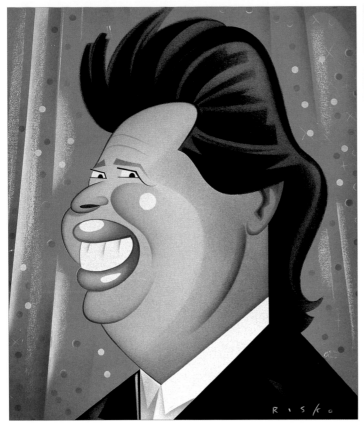

THAT BOUTON'S A REAL CARD While at first glance Stewart McKissick's illustration of Jim Bouton appears grounded in realism, it also has decidedly humorous characteristics. The illustrated parody of a New York Yankee trading card was included in a national tour of baseball art.

CLASSIC RISKO Gary Shandling falls victim to the Risko touch in *Rolling Stone*. Caricature is a very specialized form of humorous illustration, and few are as adept at it than Risko. "It always helps," says Risko, "when the subject you're caricaturing has a recognizable look and style. Like with Shandling, an important characteristic is how his hair is bushy, not wispy, and it kind of sits on his head like a helmet."

AS AMERICAN AS APPLE PIE The typical American family, at least David Sheldon's version of it, makes their way to the pages of *Travel Holiday*. While Sheldon used to create his humorous illustrations with painted gouache, he now produces them on the computer. "When I first got my computer," says Sheldon, "my clients were excited because they saw I could do some different things. . . . My goal is to have people find my work one hundred years from now and become excited about it, and I imagine as technology gets better, it'll be easier to store illustrations digitally so someone will be able to see it."

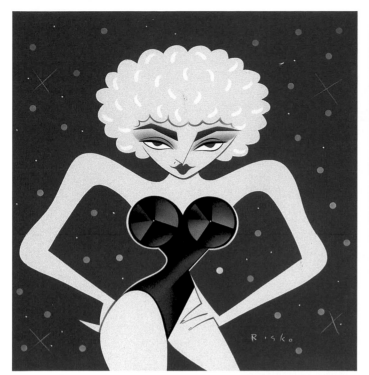

HAT'S OFF TO FUN: Pleasingly exaggerated, Kimble Mead's whimsical humorous illustrations possess a delightful level of exuberant charm.

THIS MADONNA HAS CLOTHES ON The reigning Queen of Excess is lushly caricatured by Robert Risko. As a designer, Risko fully understands the impact of understatement, and over time his caricatures have become simpler and simpler. "I think I am a minimalist," says Risko. "and I like getting down to the essence of things. You have to reach into the soul of whatever it is you're trying to capture. What I try to do is take something that we see every day and make it profound."

THEY CALL THEM CATS BECAUSE THEY'RE SO DARN CATTY A trio of kitties wrestle for the Best of Show trophy in this nifty piece by David Sheldon published in the *New Yorker*. "Humor," says Sheldon, "is based on what you think is funny. We all agree on what's sad or heart-wrenching, but what we think is funny is as different as what foods we like to eat. And I've heard people say that comedy is much more difficult to do than drama, and I think that's true. Timing is much more difficult than it looks."

BENNY

MORDECAI

STEVE

DOGDERBEK

RUSS

WARTS AND ALL Five of Friedman's ''Grown Men Who Sell Comic Books'' cartoons. Even while making his living in underground comics, Friedman was never afraid to bite the hand that fed him. (I'd like to think that Steve has a nice personality, but I'd keep the knives and power tools away from Mordecai.)

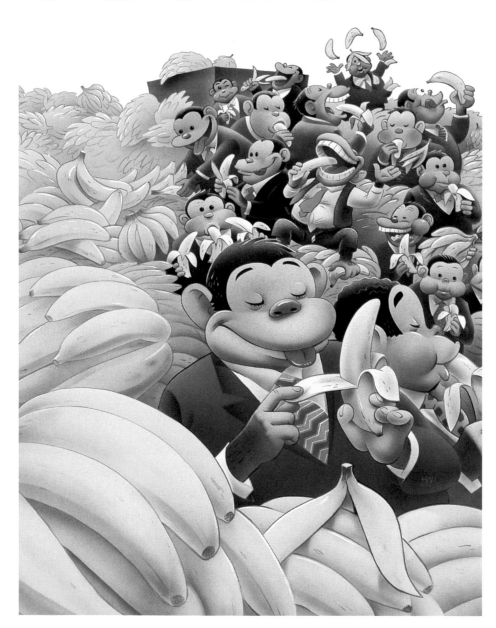

YES, WE HAVE SOME BANANAS: Half monkey, half human, it would be tough to avoid Gary Hallgren's banana-munching characters after encountering them with *Forbes* magazine, and one could only guess what they're meant to illustrate. In this case, Hallgren's creatures illustrate a juicy quote something to the effect that ''mutual fund managers are a lot like monkeys—they seem to wind up with a lot of bananas.''

HUMOR ALONG THE INTERSTATE While humorous illustration is generally found in more traditional places like magazines or greeting cards, it does occasionally surface in weird places—like forty feet in the air alongside Route 66 in Tulsa. Kim Wilson Brandt's brash humorous illustration style was deemed so ideal for a *Tulsa World* ad campaign that the newspaper's agency hired Eversz to design five billboards.

FUN WITH DEFECTIVE BRAIN MATTER Mark Marek humorously depicts that legendary moment when the brain cells of Frankenstein's monster reanimated. Note the professions of the previous owners of the brains that appear pickled in jars below.

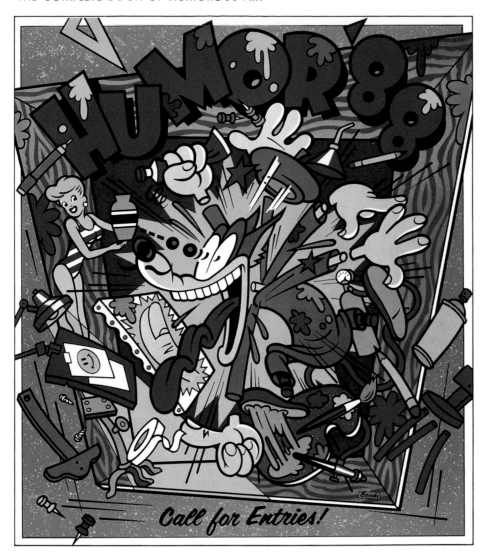

HOMAGE TO TEX AVERY If humorous illustration is used with greater frequency by art directors, Lou Brooks theorizes that it's because our pop culture is riddled with humor.

MAYHEM AT THE MALL When dog meets cat, the results can be devastating, especially the meeting takes place amid a horde of holiday shoppers. Here H.B. Lewis uses his strong compositional skills, meticulous staging ability and keen sense of character design to create a scene rife with animated humor.

A NEW DIMENSION IN CARICATURE Hanoch Piven's brilliantly inventive caricatures are studies in simplicity, and Piven engenders surprisingly accurate celebrity likenesses with nothing more than a little paint and a few found objects. His caricature of Barbra Streisand uses a microphone as a proboscis; a broken Oreo becomes Roseanne's mouth; Prince Charles is really a broken bread board; Steven Spielberg's beard and moustache are strips of film; and Jesse Jackson's mouth is a speaker.

My sister didn't want to be on the boat. She curled up and fell asleep. Rain clouds passed by. The sun came out.

KIDDING AROUND Seymour Chwast's lighthearted colored pen line humorous illustration approach is delightfully applied to the children's book *My Sister Says Nothing Ever Happens When We Go Sailing*. When unfolded, the art is six feet wide.

My Sister Says Nothing Ever Happens When We Go Sailing

Story by
Harriet Ziefert

Pictures by
Seymour Chwast

JULIA SEES PRINT While the book *Tea With Julia* was illustrated by David Sheldon, it was never published (long story), but it should have been. Yet the very least we can do here is get Sheldon's marvelously whimsical cover into print. Although it happens "less and less," occasionally an art director will ask Sheldon to slightly change his characters. "I hate it," fumes Sheldon, "when they ask me to make my girl characters cuter. Usually, I'll only hear a comment like that from an art director at a smaller magazine, and I've found that the art directors at the big magazines let you do what you do best or they wouldn't be calling. Also, it's often the editor who's making those kind of visual judgments and the art director has to deliver the word."

POLITICALLY-INCORRECT PIX Each week, I'm called on by *The Washington Post* to help write and illustrate their phenomenally popular contest, the *Style Invitational*. I'm usually given very short notice, sometimes learning of the contest specifics noon, and needing to fax final art to Washington by 5pm.

FUMING FOLKS A perusal of *American Showcase* will reveal at least four younger illustrators who make every effort to slavishly steal Mike Lester's trademark humorous illustration style. Wonderfully original, Lester's style developed from a variety of subtle influences into what it is today. "I see a lot of young people" says Lester, "who look for a style as if they were buying a wardrobe."

THE CHANGING OF THE CARD A concept of my own creation, these "Comic Caper" cards incorporate a spinning dial that advances three or four complete dialogue changes within the word balloons. For the ten cards, I was able to negotiate with Paramount Cards a substantial upfront fee plus a 7% royalty over the life of the cards.

THE TEMPTATION TO COAST Having firmly established himself as one of the nation's foremost humorous illustrators, it would be easy for Lou Brooks to become lazy with his work, but these three examples testify to Brooks's desire to modify his style. It's hard to beat that zing you get when you take a risk and come up with something new."

TURNING A POSITIVE INTO A NEGATIVE While the bold lines of Robert Zimmerman's humorous illustrations are reminiscent of woodcuts, Zimmerman actually creates his compelling graphic art on the computer.

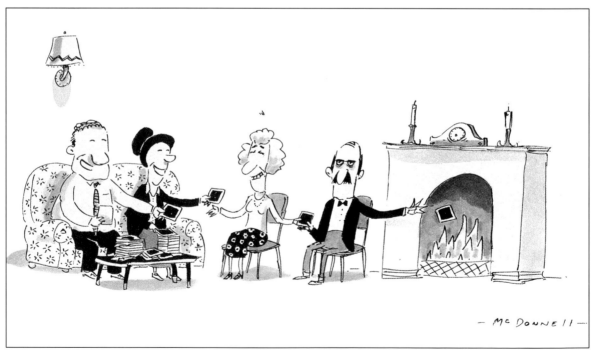

NIX ON THE PIX By carefully staging his action so that the reader moves from left to right, Patrick McDonnell creates this hilarious idea (haven't we all been there?). ''The fun part of what I do,'' says McDonnell, ''is finding different humorous ideas that enable you to solve problems.'' The piece illustrates a Russell Baker in the *New York Times* wondering why tourists take photographs in the first place.

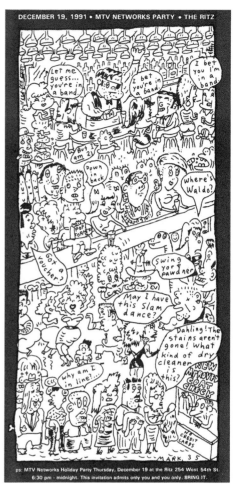

GARDEN PARTY While this humorous illustration incorporates limited background imagery, often Mike Lester's characters appear without any distant ephemera. "I really need to hire a background artist," says Lester.

**LET'S PARTY!
(HUMOROUSLY, OF
COURSE)**
"For a while now," says Mark Marek, illustrator of this MTV holiday party invitation, "I've been signing my illustrations with only my first name and age because that's the way I'd remembered kids doing it in kindergarten." But because of his advancing years, Marek says, "I may have to stop doing that because I might lose work."

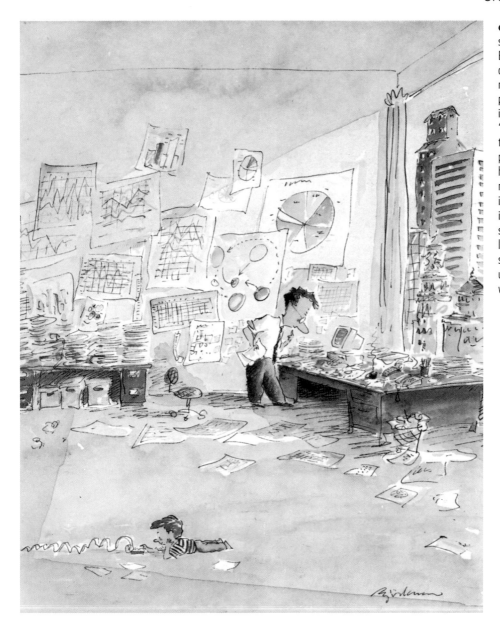

CALCULATED IDEA The sheer simplicity of Steve Bjorkman's juxtaposition of dad and son makes this humorous illustration sing. "People have this romantic view of illustrators," says Bjorkman. "They think 'oh gee, you get to sit around all day and draw pictures.' A lot of what I do has to do with running a business, a lot of it is generating ideas or just thinking. When it comes to drawing, it's a slow process of putting down lines, not liking them, and starting over and over again until you get it the way you want it."

LETTERED LEVITY H.B. Lewis creates the niftiest typographic treatment for the alphabet since the invention of Helvetica. Wonderfully whimsical, Lewis's delightful humorous illustrations are a veritable feast for the eyes, and one could study and appreciate the subtleties of this poster for the Minnesota Literacy Council for hours—or even days.

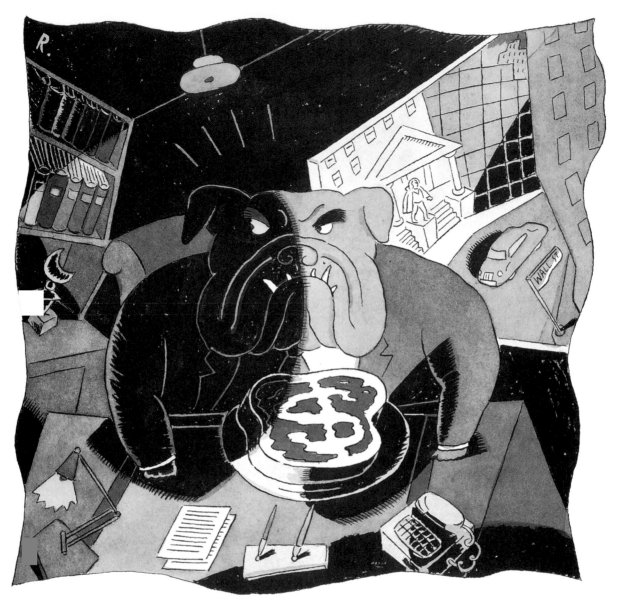

MEAT-EATING MUTT:
Marc Rosenthal's sophisticated, graphic approach is decidedly humorous, yet his illustrations work equally well as intoxicating designs due to their bold use of color, composition, and heavily blackened focal points.

ILLUSTRATOR PROFILES

In the interest of being better able to put their interview comments into proper perspective, the following biographical data is intended to provide you with additional information about the twenty humorous illustrators featured in this book.

GARY BASEMAN

Born: September 27, 1960 • *College:* UCLA • *Degree:* Communication Studies, 1982, • *Began Professional Career:* 1984 • *Books:* American Illustration 7,8,9,10,11 and 12 • *Home:* Brooklyn, New York

Having secured numerous high profile editorial assignments in the late 1980s and early 1990s, Gary Baseman has started to make an impact in advertising, perhaps a sign that Madison Avenue has finally accepted the fact that Freudian noses and green skin might not be that bad after all. Jokingly, Baseman describes his style as "post-neo-contemporary-modern," and his work has been commissioned by clients as diverse as *Time*, Nike, *Forbes*, and Gatorade.

STEVE BJORKMAN

Born: December 15, 1951 • *College:* Trinity College (Deerfield, IL) • *Degree:* B.A. in English and Secondary Education • *Began Professional Career:* 1978 • *Books: I Hate English*, Scholastic, 1989; *In 1492*, Scholastic, 1993; *Seeds*, Houghton Mifflin, 1994; *The One-Minute Bible for Kids*, Garborgs, 1993 • *Home:* Irvine, California

Of the twenty humorous illustrators interviewed for this book, no one has more products, cards and coffee mugs out there ringing up royalties than Steve Bjorkman. For Bjorkman, diversification seems to be the key to success, and he encourages other humorous illustrators to work for royalties rather than up-front paychecks. Bjorkman's clients have included AT&T, Scholastic, NYLife, Saatchi and Saatchi Advertising, BBDO, and Recycled Paper Greetings.

LOU BROOKS

Born: September 5, 1944 • *Began Professional Career:* 1965 • *Home:* Ocean City, New Jersey

A true pioneer in humorous illustration, Lou Brooks's graphic approach to his work came out of his intense knowledge of newspaper production, which he learned as a teen working at the *Philadelphia Bulletin*. The question isn't who *has* Brooks worked for, it's who *hasn't* he worked for. From *Rolling Stone* to *Playboy*, MTV to Anheuser Busch, RCA to Burger King, Brooks's bold graphics are hard to miss.

SEYMOUR CHWAST

Born: August 18, 1931 • *College:* Cooper Union • *Degree:* Honorary Ph.D. from Parsons School Of Design • *Began Professional Career:* 1951 • *Books: Bra Fashions by Stephanie,* Warner Books, 1994; *Paper Pets: Make Your Own (3) Dogs, (2) Cats, (1) Parrot, (1) Rabbit, (1) Monkey,* Abrams, 1993; *Alphabet Parade,* Harcourt Brace, 1991 • *Home:* New York, New York

A designer as much as an illustrator, few in the graphics industry don't know Seymour Chwast's work, or how historically important it is. Able to work in a dizzying array of styles ranging from the most somberly serious to the unapologetically lighthearted, Chwast truly is a creative chameleon. His humorous illustrations have appeared in such publications as *Time, Esquire,* the *New York Times,* and the *Atlantic,* to name but a very few.

DAVID COWLES

Born: November 3, 1961 • *Began Professional Career:* 1983 • *Books: Big Towns, Big Talk:* Entertainment Weekly *Guide To The Movies* • *Home:* Rochester, New York

Phenomenally talented as a caricaturist, David Cowles only recently began experimenting with oddly-colored planes of tone in his distorted celebrity caricatures, but has received almost overnight recognition for infusing the art form of caricature with a creative shot in the arm. As relatively young as Cowles is, his work is often imitated by established humorous illustrators and caricaturists a half dozen years his senior. Cowles celebrity caricatures appear fifty-two times a year in *Entertainment Weekly,* and have also appeared in *Los Angeles* magazine, the *Washington Post,* the *Village Voice,* and the *Chicago Tribune.*

JACK DAVIS

Born: December 2, 1924 • *College:* University of Georgia, Art Student's League (NYC) • *Began Professional Career:* 1946 • *Books: Meet Abraham Lincoln,* Random Books, Young Readers, 1989; *The No Name Man on the Mountain,* Harcourt Brace and World, 1964 *More Headlines,* by Jay Leno Warner Books, 1990 • *Home:* St. Simons Island, Georgia

ROBERT DE MICHIELL

Born: May 2, 1958 • *College:* Rhode Island School Of Design • *Degree:* Illustration, 1980 • *Books:* Hot Potatoes: The Collected Recipes, Wit & Wisdom of Well-Known Potatoe Lovers, Doubleday, 1993; *Goodbye Jumbo . . . Help Cruel World,* Viking Penguin, 1993; *The Gay and Lesbian Handbook to New York City,* Penguin, 1994 • *Home:* New York, New York

Calling his work "pretty delicately arranged," Robert de Michiell's humorous illustrations nonetheless have a certain level of boldness, if not bravado. Influenced by the graphic art of the 1920s and 1930s, de Michiell sees his work as nothing short of contemporary, a point reaffirmed by the fact that de Michiell's funny graphics appear in Manhattan's hippest magazines. *Premiere, Entertainment Weekly* and the *New Yorker* are among de Michiell's regular clients, and he has also done advertising work for Target, T.G.I. Fridays, and the New York State Lottery.

PETER DE SÈVE

Born: December 12, 1958 • *College:* Parsons School Of Design • *Degree:* Bachelor of Fine Arts, 1980 • *Began Professional Career:* 1980 • *Book/Video:* Finn McCoul, Rabbit Ears, 1991 • *Home:* Brooklyn, New York

Approaching humorous illustration in a painterly fashion, Peter de Sève's lush, rich work has appeared in the *New York Times Magazine, Newsweek, New York Magazine,* and at this writing on four 1994 covers of the *New Yorker.* But de Sève has also created humorous illustration for advertising clients such as AT&T, IBM, NYNEX, and the Book of the Month Club. Recently, he completed doing various character designs for the soon to be released animated Disney feature, 'The Hunchback Of Notre Dame.'

DREW FRIEDMAN

Born: September 21, 1958 • *College:* School Of Visual Arts • *Degree:* Bachelor of Fine Arts, 1981 • *Began Professional Career:* "In the late 1970s" • *Books:* Any Similarity to Persons Living or Dead Is Strictly Coincidental, Fantagraph Books, 1990; *Warts And All,* Penguin, 1990; *Private Lives Of Public Figures,* St. Martin, 1993; *Private Parts,* Simon and Schuster, 1993 • *Home:* Shohola, Pennsylvania

A long time fixture in pseudo-underground comics, Drew Friedman recently began applying his decidedly meticulous stipple technique to humorous illustrations, although he has modified the technique in the interest of expediency. Employing just a touch of distortion, Friedman's intense celebrity caricatures appear down right surreal, if not photographic. His delicious dot-by-dot drawings have appeared in such publications as *GQ, Time, Rolling Stone,* the *New Yorker,* and *MAD,* and for such clients as Time Warner, CBS, MTV, Rhino Records and Topp's.

STEVEN GUARNACCIA

Born: October 25, 1953 • *College:* Brown University • *Began Professional Career:* 1977 • *Books:* *Madam, I'm Adam*, Scribner's, 1990; *If I Had A Hi-Fi*, Dell, 1992; *Anansi*, Rabbit Ears, 1991; *A Stiff Drink and a Close Shave*, Chronicle, 1995 • *Home:* Montclair, New Jersey

The humorous illustrator's humorous illustrator, Steven Guarnaccia is as interested in creating a solid idea, as he is with creating a solid drawing. Guarnaccia's humorous illustrations have appeared in the *New Yorker*, *Esquire*, and *Metropolitan Home*, he has done work for such corporate clients as MCI, American Express, Barneys and Federal Express. He has also created exceptionally cool designs for Swatch watches as well as a line of neckties for Rooster.

MIKE LESTER

Born: March 3, 1955 • *College:* University Of Georgia • *Degree:* Bachelor Of Fine Arts, 1977 • *Began Professional Career:* 1978 • *Books:* *Kids Make Pizza*, Prima Publishing, 1994; *Santa's New Suit!*, Price Stern, 1993; *Shoot Low, Boys, They're Ridin' Shetland Ponies*, Peachtree Publishers, 1985 • *Home:* Rome, Georgia

Describing his humorous illustration style as ''post-nasal modern,'' Mike Lester's work is hilariously original. Lester's observational skills are exceptionally keen, and when he combines this with his ability to draw action, his humorous illustrations can cause one to laugh out loud, spit-take their coffee, or both. Primarily an advertising illustrator, Lester has done work for such clients as Domino's Pizza, Quaker Oats, Pepsi, Coor's, and AT&T.

MARK MAREK

Born: June 5, 1956 • *College:* University of Texas At Austin • *Degree:* Bachelor Of Fine Arts In Studio Painting, 1978 • *Began Professional Career:* 1981 • *Books:* *New Wave Comics*, Manhattan Design, 1983; *Patient's Revenge*, Simon and Schuster, 1983; *Hercules Amongst the North Americans*, Viking Penguin, 1986; *Two-Fisted Management*, Pharos, 1990 • *Home:* Haworth, New Jersey

If he has his way, Mark Marek will be talking about humorous illustration in the past tense. Having established himself as one of the most creative, cutting-edge practitioners of the art form, Marek has become somewhat disillusioned with humorous illustration, or better yet, has bought a computer. It's the computer that has opened up doors for Marek in animation, an area that he has always been keenly interested in, so his efforts of late have included animation development for MTV and Nickelodeon. Marek's illustrations have appeared in such publications as *Rolling Stone*, *Details*, *PC World* and *Regardie's*.

BILL MAYER

Born: October 25, 1951 • *College:* Ringling School Of Art • *Began Professional Career:* 1972 • *Books:* Golf-O-Rama: The Wacky Nine-Hole Pop-up Mini-Golf Book, Hyperion, 1994 • *Home:* Decatur, Georgia

Viewing his humorous illustrations as "tactile therapy," a study of Bill Mayer's work reveals that his style seems to be in a constant state of flux. While the Mayer of the mid-1990s has a certain artistic preference for airbrushed monsters and creatures that go bump in the studio, there's no telling what Mayer's work will look like in a scant year or two. In fact, pull this book out in 1997 and do your own comparison. To be sure, Mayer's work is visually stunning, and awe-inspiring—especially for someone who has yet to figure out how to unclog his airbrush, let alone use it. Primarily focused on advertising projects, Mayer has done work for Pepsi, McDonald's, Scripto, Coca-Cola, and IBM.

PATRICK MCDONNELL

Born: March 17, 1956 • *College:* School of Visual Arts, NYC • *Degree:* Bachelor of Fine Arts • *Began Professional Career:* 1979 • *Books:* Bad Baby, Ballantine, 1988; Krazy Kat: The Art of George Herriman, Abrams, 1986 • *Home:* Metuchen, New Jersey

Known for his understated, cartoony illustration style, Patrick McDonnell is making a concerted effort to begin a new career as a comic strip artist. His daily strip, *Mutts*, debuted in the fall of 1994 and is syndicated by King Features, the syndicator of his cartooning idol, George Herriman. McDonnell's work has appeared in countless magazines including *Parents*, *Parade*, *Sports Illustrated*, *Time*, and *Reader's Digest*.

EVERETT PECK

Born: October 5, 1950 • *College:* Cal State Long Beach (CA) • *Degree:* B.F.A., Illustration, 1974 • *Began Professional Career:* 1974 • *Books:* Duckman: The Series, Topps, 1994; Mose the Fireman, Rabbit Ears, 1994 • *Home:* Leucadia, California

Multifaceted in his work, Everett Peck's approaches humorous illustration from a fine art perspective. While he spends a considerable amount of time these days overseeing his "Duckman" series on the USA Network, Peck's work has been commissioned by such clients as BBDO, Acura Cars, Rabbit Ears, Asatsu Electronics, *Rolling Stone*, *Esquire*, *Time*, and the *Atlantic*.

ROBERT RISKO

Born: November 11, 1956 • *College:* Kent State University • *Degree:* Fine Art • *Began Professional Career:* 1976 • *Books: On Your Own* by Brooke Shields, Villard, 1985; *The Complete Book of Caricature*, North Light, 1991; *The Savage Mirror*, Watson Guptill, 1992 • *Home:* New York, New York

One of the nations' most prolific caricaturists, Robert Risko's work is awe-inspiring. Solidly grounded in the influential roots of the Art Deco and Cubist movements, Risko first set out to do the "quintessential" caricature of each celebrity he was assigned to lampoon. Having done work for every major consumer magazine, from *Time*, to *Vanity Fair*, *Newsweek* to *Vogue*, a Risko caricature of Roseanne Barr was once killed by the comedian because she thought the artist had made her look "too fat."

ARNOLD ROTH

Born: February 25, 1929 • *College:* University of the Arts, Philadelphia • *Began Professional Career:* 1951 • *Books: Pick a Peck of Puzzles*, WW Norton; *Crazy Book of Science*, Grosset & Dunlap; *Comic Book of Sports*, MacMillan; *A Sports Bestiary*, McGraw Hill, 1982 • *Home:* New York, New York

Known for injecting an extraordinary level of graphic mayhem into his work, Arnold Roth's humorous illustrations have appeared in such magazines as *Time*, *Sports Illustrated*, *TV Guide*, *Playboy* and *Life*. Having always approached his work from a comic perspective, Roth seems more comfortable with the moniker of cartoonist rather than humorous illustrator, and he has always felt that both his ideas and art should work symbiotically.

DAVE SHELDON

Born: May 14, 1957 • *College:* Miami University, B.F.A. 1980; University of Cincinnati, M.F.A., 1983 • *Began Professional Career:* 1985 • *Home:* Independence, Kentucky

Greatly influenced by animation design and graphics of the 1950s and 1960s, David Sheldon's humorous illustrations of today are created on the Macintosh. Working from a suburb of Cincinnati, Sheldon now modems his art directly to such magazines as *Entertainment Weekly*, *Sports Illustrated*, *Child*, *Parenting*, and *Interview*.

ELWOOD H. SMITH

Born: May 23, 1941 • *College:* Chicago Academy of Fine Arts • *Began Professional Career:* 1961 or 1962 • *Books:* The See and Hear and Smell and Taste and Touch Book, J. Philip O'Hara, 1973; A Ball Of Yarns, Harlin Quist, 1977 • *Home:* Rhinebeck, New York

Once greatly influenced by the cartooning styles of the 1930s and 1940s, a study of the breadth of Elwood H. Smith's work reveals just how much his humorous illustration has evolved and become truly original. One of the most high profile practitioners of the art form, you'd be hard-pressed to find an agency art director who wasn't aware in some way of Smith's graphic work. Dividing his time between advertising and editorial assignments, Smith's humorous illustrations have been commissioned by *Time*, *Newsweek*, Random House, BBDO, and J. Walter Thompson.

BOB STAAKE

Born: September 26, 1957 • *College:* University of Southern California • *Began Professional Career:* 1987 • *Books:* Headlines, by Jay Leno, Warner books, 1989; Humor and Cartoon Markets, Writer's Digest Books, 1990, 1991, 1993; True and Tacky 2, Topper, 1992; The Complete Book of Caricature, North Light, 1991 • *Home:* St. Louis, Missouri

Known for his spontaneous, high-energy style, Bob Staake's humorous illustrations have been applied to everything from magazines to books, animation to greeting cards, cereal boxes to CD-ROM games. Having trained to become a political cartoonist, Staake made a career change to humorous illustration when he moved from his hometown of Los Angeles to St. Louis. Recognized by art directors and his peers as having one of the fastest pens in the country, and possibly the hemisphere, Staake's work has been commissioned by the *Washington Post, Parents, Nickelodeon, Sports Illustrated for Kids*, Doubleday, The Children's Television Workshop, Ralston Purina, and AT&T, and others too numerous to mention.

(Biographical information for Bob Staake written by J. Reid Kendall)

131

PERMISSIONS

INDEX

More Great Books for Illustrators!

The Complete Book of Caricature—Extensive samples from top professionals combine with step-by-step lessons and exercises to make this the definitive book on caricature. *#30283/$18.99/144 pages/300 b&w illus.*

How to Draw and Sell Cartoons—Learn how to create every type of cartoon—from political to the simply funny—with advice on developing a style, theme, series and strips. *#07666/$19.95/144 pages/74 color, 300+ b&w illus.*

Getting Started Drawing & Selling Cartoons—Randy Glasbergen, creator and writer of the syndicated strip "The Better Half" teaches you step by step, how to draw funny cartoons—and how to make money selling them. *#30489/$19.95/128 pages/150 b&w illus.*

How to Draw and Sell Comic Strips—You'll find everything you need to transform your three-dimensional ideas into salable two-dimensional comic strips. *#30009/$19.99/144 pages*

Create Your Own Greeting Cards and Gift Wrap with Priscilla Hauser—You'll see sponge prints, eraser prints, cellophane scrunching, marbleizing, paper making and dozens of other techniques you can use to make unique greetings for all your loved ones. *#30621/$24.99/128 pages/230 color illus.*

Artist's & Graphic Designer's Market—This marketing tool for fine artist and graphic designers includes listings of 2,500 buyers across the country and helpful advice on selling and showing your work from top art and design professionals. *#10434/$23.99/720 pages*

How to Airbrush T-Shirts and Other Clothing—Make a statement—or a living—by painting clothing. You'll learn how to create popular subjects and lettering styles, design stencils—plus, how to price and sell your work! *#30614/$24.99/128 pages/200+ color, 15 b&w illus./paperback*

Airbrush Action 2—Jumpstart your creativity with over 400 fresh, exciting images from top airbrush artists. You'll find works in acrylic, gouache and water-color in full color with credits. *#30662/$29.95/192 pages/450+ color illus./paperback*

Getting Started in Airbrush—A step-by-step guide to all the basic-level airbrush techniques used to create a wide variety of effects when doing commercial illustration or airbrushing a T-shirt. Key airbrushing techniques are shown and described in action. *#30514/$22.99/128 pages/200 color, 30 b&w illus./paperback*

Basic Airbrush Painting Techniques—Beginning airbrush artists—find everything you need to know, from choosing the right materials to creating dazzling airbrush effects. *#30570/$19.95/128 pages/230 color illus./paperback*

How to Make Money with Your Airbrush—The only how-to-sell guide available for airbrush artists, including everything from identifying markets, to how much to charge, to how to keep track of business and tax details. *#30421/$18.95/128 pages/30 b&w illus./paperback*

How to Write and Illustrate Children's Books and Get Them Published—Reach into the world of kids (ages 2-11) with your words and illustrations. This truly comprehensive guide demonstrates how to bring freshness and vitality to children's text and pictures. *#30082/$22.50/144 pages/70 color, 45 b&w illus.*

The Very Best of Children's Book Illustration—Spark your creativity with nearly 200 reproductions for the best in contemporary children's book illustration. *#30513/$29.95/144 pages/198 color illus.*